T0016869

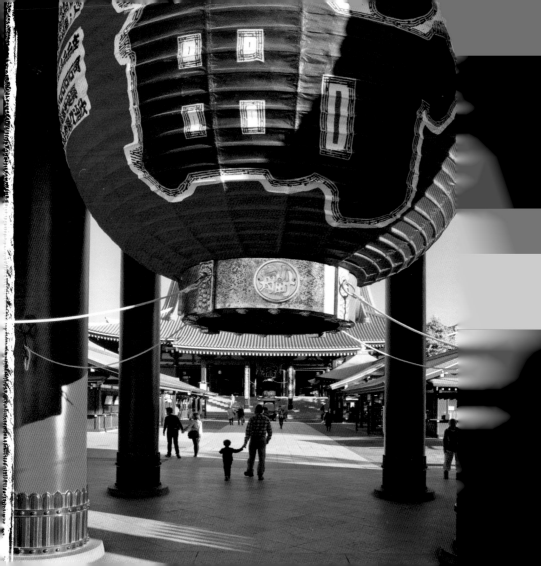

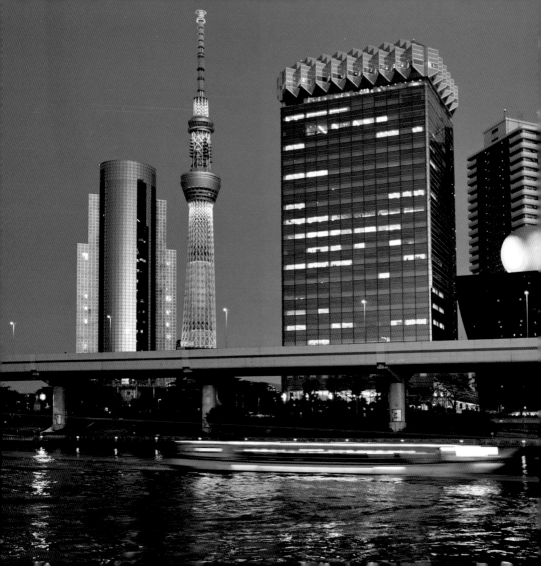

The Little Book of
Tokyo

Ben Simmons

TUTTLE Publishing

Tokyo | Rutland, Vermont | Singapore

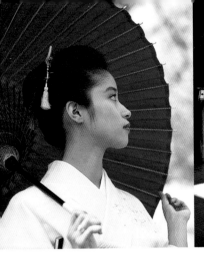

Above, left to right A traditional springtime beauty; Early morning at Senso-ji Temple; The spherical observation platform of Fuji TV Headquarters, designed by renowned 20th-century Japanese architect Kenzo Tange; A wall-sized anime damsel in Akihabara.

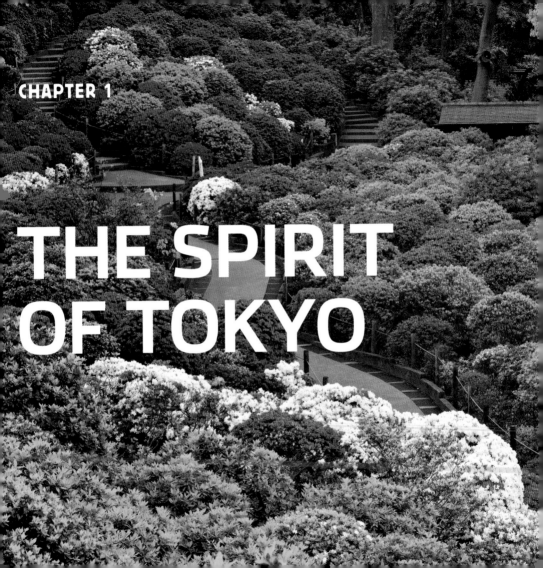

THE SPIRIT OF TOKYO

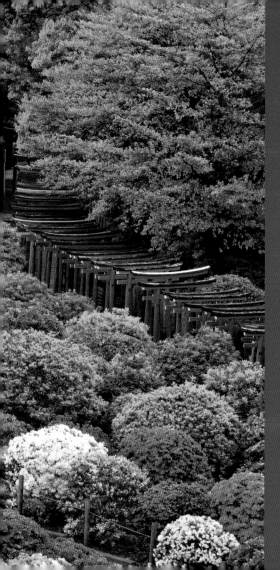

Tokyo's vibrant spirit is built around a core of native Shinto blended with imported Buddhist and Christian faiths shaped over centuries, but indubitably spiced heavily with the lasting influence of Edo culture and the unbounded energy of non-stop migration from all points of the archipelago. Migrants to the city have always quickly adjusted, adopting the new mores, manners, and sense of superiority the capital engenders. Edo, renamed Tokyo in 1868, readily absorbed the newcomers and also embraced a steady stream of festivals year round, with ritual visits to hundreds of shrines and temples throughout the city.

Edokko, the children of Edo-born parents, sprang from merchants, artisans, moneylenders, and shop owners, and were known to be proud, assertive, direct, impatient, and fun loving—but with sharp mercantile skills. The spirit of modern Tokyo is mercantile beyond measure, with friendships and life itself centered on work for adults, serious school for children, and hyper-shopping for all. The city's spirit moves everyone and everything through intricate patterns at a blurring speed and with astonishing accuracy. Food, fun, and entertainment in Tokyo are as carefully scheduled as any company workforce or clockwork city train.

A tunnel of *torii* gates through Nezu Shrine's azalea garden.

Shinto Shrines

Below left A *miko* shrine maiden making traditional hair ribbons.

Below A vermilion path of Shinto *torii* gates at Nezu Jinja.

The Agency for Cultural Affairs lists nearly 1,500 Shinto shrines in Tokyo, but there are countless other small unrecorded shrines tucked away on the city's back streets. The shrines for Japan's indigenous Shinto faith in Tokyo range from the largest, most sacred Meiji Jingu, with its solemn forest of 100,000 donated trees, to

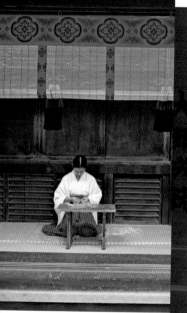

tiny neighborhood shrines tended by local residents. Shinto's *kami* spirits are tied to nature's elements, and many of Tokyo's shrines were founded in spots of natural beauty, helping to preserve green pockets sprinkled around the city, remnants of the natural landscape. Most shrines have distinctive *torii* gates,

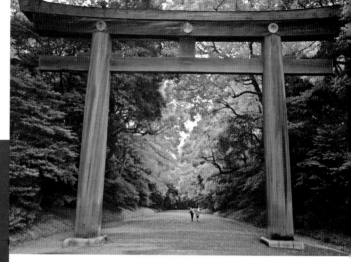

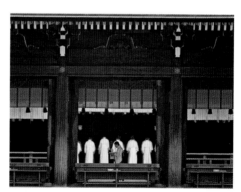

Above A shrine's distinctly simple *torii* gate symbolizes the entrance into the sacred realm.

Left A shrine's inner precincts are reserved for ritual ceremonies.

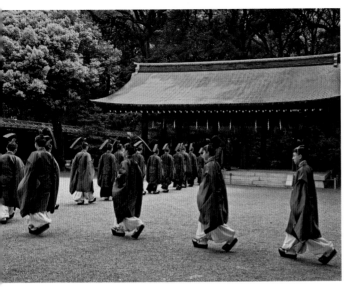

a font of running water for purification, guardian *komainu* lion-dogs or *kitsune* fox statues, and cloud gray stone *toro* lanterns.

Meiji Jingu is a memorial shrine for Emperor Meiji, who marked the beginning of Tokyo and modern Japan, and his consort Empress Shoken, a revered advocate for charity and women's education. Located next to the trendy teen town of Harajuku, the shrine staff are kept busy from dawn to dusk reminding visitors that Meiji Jingu is a sacred place. An historic shrine, Yushima Tenmangu in old *shitamachi*, attracts students with the enshrined God of Learning, and lovers of plum blossoms with its 300 Japanese apricot trees. Tokyo's Nezu Shrine hosts an endless stream of visitors when its hillside azalea garden blooms into a sweeping palette of gleaming reds. Asakusa Shrine is overshadowed by the adjacent Senso-ji Temple, but a closer look reveals an original Edo-era shrine that has miraculously survived all of the city's recurrent devastation.

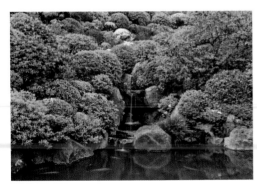

Above A procession of Shinto priests in ceremonial robes.

Left A delicate waterfall and *koi* carp in the azalea garden pond at Nezu Shrine.

Opposite below The centuries-old Ana Inari auxiliary shrine at Shina-gawa Jinja.

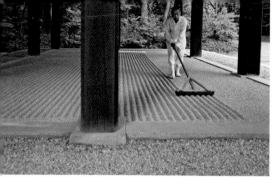

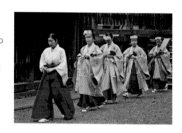

Left Zen-like preparation for a gathering of Shinto priests.

Right A procession of *miko* shrine maidens in ceremonial robes.

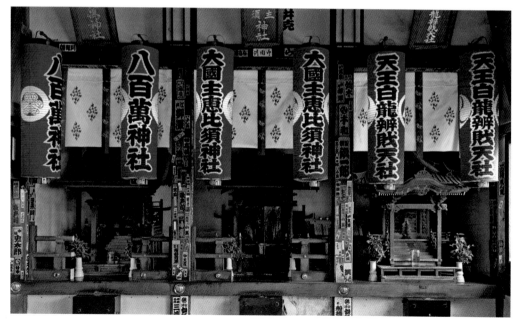

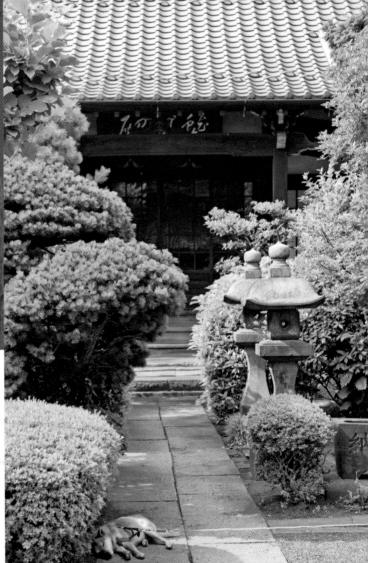

Buddhist Temples

Above Buddhist scholar and monk Tamura Kanji at Enjyu-ji Temple.

Right Seeking shade and enlightenment at Myogyo-ji Temple in Yanaka.

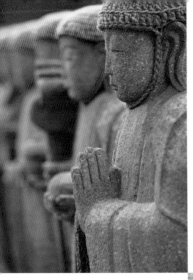

Left A solemn row of stone bodhi-sattva *jizo* brightened by red knitted caps.

Right A beautifully weathered crimson gate at Zojo-ji Temple.

Below Monks honor revered founder Nichiren Shonin where he passed away in 1282 at Ikegami Honmon-ji Temple.

The venerable Senso-ji is the spiritual soul of Tokyo's temples, and Shibamata Taishkuten is the most beautiful gem amongst the city's nearly 3,000 Buddhist temples. Senso-ji in Asakusa has been attracting pilgrims and visitors for centuries, but far fewer venture to the more remote Shibamata district. The *kawara* tile roofs of many lesser-known temples can beckon from along train tracks and streets in every part of the city. Many Tokyo temples have, unfortunately, forfeited portions of their grounds and gardens to encroaching

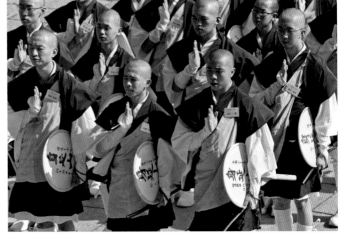

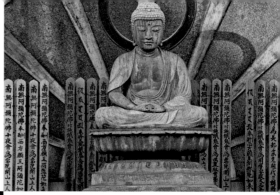

Above A bronze Buddha meditates in the temple cemetery at Eko-in.

Right Kofuku-ji's temple gate in *shitamachi*'s Mukojima.

Top A bronze statue of founding monk Shinran stands sentinel in the autumn garden at Zonmyo-ji Temple.

Above The 150-year-old wooden concession for snacks and souvenirs at Zoshigaya Kishimojin-do Temple.

developments or simply for use as parking space.

Eiko-in Temple must be sought out, squeezed between surrounding buildings in Ryogoku where it was once a more spacious venue hosting sumo matches. Recently, young women visit Eiko-in to rub the face and hand of its bronze sculpture of a lovely Edo courtesan, seeking beauty and good fortune. Sengaku-ji is a Zen Buddhist temple located near Shinagawa, known for the legendary Forty-seven Ronin samurai who are buried there alongside the master they avenged on a snowy Edo evening in December 1702. Sengaku-ji's monks are now fighting a losing battle against a construction project right at their temple gate.

Right A bronze relief of an Edo beauty at Eko-in Temple, rubbed for good fortune and good looks.

Below Zoshigaya Kishimojin-do's venerable Honden main hall was built in 1664.

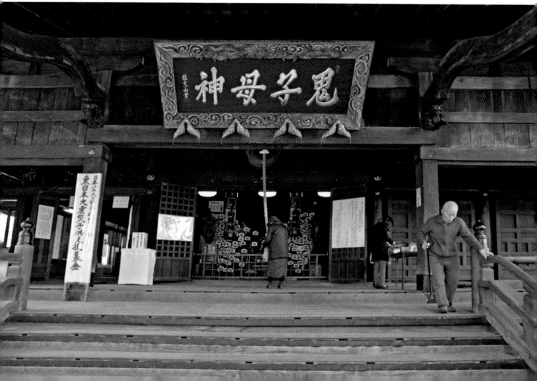

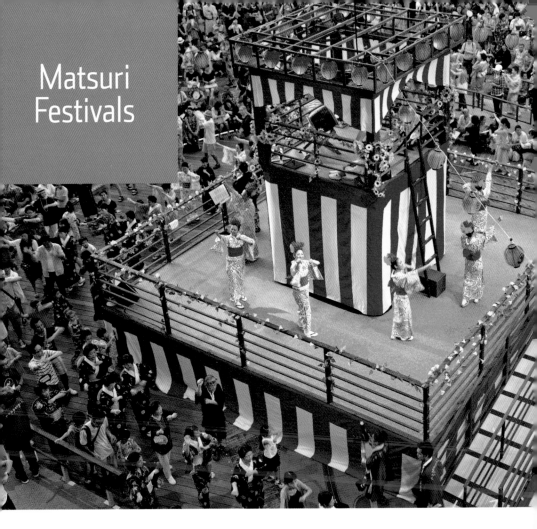

Matsuri
Festivals

Left The Bon Odori summer festival at Roppongi Hills.

Right A folk dancing performance at Meiji Shrine's Spring Grand Festival.

Below right Geisha parade at Haneda Edo Festival.

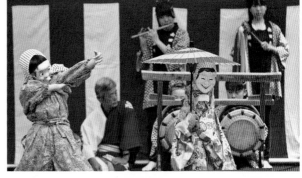

Tokyo's traditional *matsuri* festivals lend continuity and evoke history in a metropolis whose most enduring characteristics are change and impermanence. Tokyo festivals provide a renewing energy and a soothing tonic for the city's relentless growth and modernization. *Matsuri* can be Tokyo's most spiritual celebrations, joyous occasions for residents to step out of their normal roles and routines. Festivals encourage reflection and reverence, and maybe even getting dirty and sweaty. Tokyo has traditional shrine festivals and temple fairs and markets each month throughout the year.

Major Shinto shrine festivals include Sanja Matsuri, held each May in Asakusa, Kanda Matsuri, celebrated every two years, and Meiji Shrine's festivals with sacred

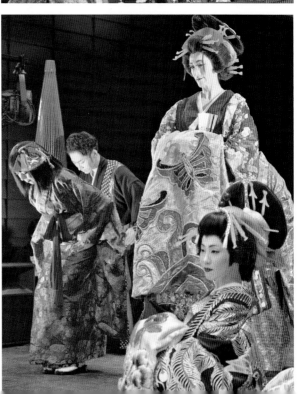

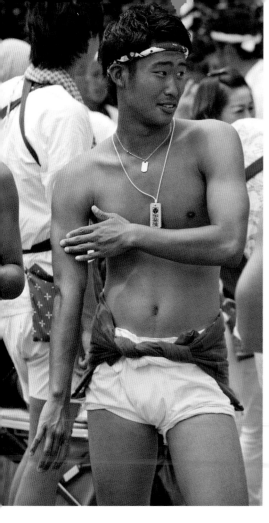

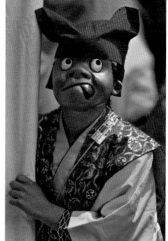

Left A young folk dancer in a comical *hyottoko* mask.

Far left Summer heat at Urayasu's "Three Shrine" Festival.

Right Young dancers primp before Koenji's Awa Odori procession.

gagaku music in the spring and fall. Each August in western Tokyo, the Koenji Awa Odori Festival, created by urban migrants from Tokushima, attracts dance troupes from all over Japan. Sanja is the largest and wildest of Tokyo's festivals, with dozens of *mikoshi* portable shrines paraded through Asakusa's streets with great delight. The *mikoshi*, lashed to shoulder poles and decorated with silk, gold bells, and a divine phoenix on top, are carried by teams of undeniably cute children, enchanting women, and men as solid as rugby athletes, some sporting great swollen knots on their shoulders.

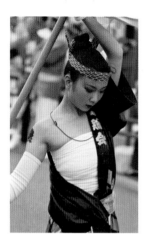

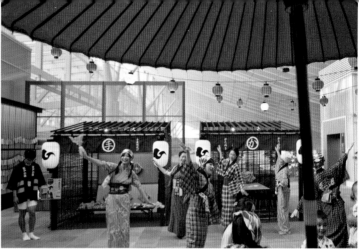

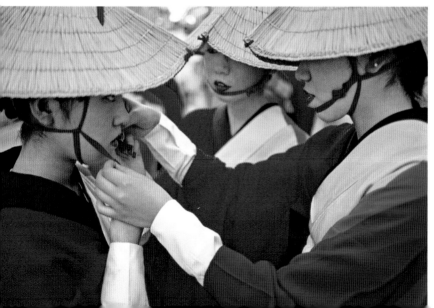

Above left A traditional festival costume augmented with modern make-up and an appliqué rose.

Above Folk dancers in flight at Haneda International Airport.

Left Adjusting a *kitsune* fox mask at Meiji Jingu.

Below A festival bandwagon trimmed with *chochin* lanterns at Asakusa's Sanja Matsuri.

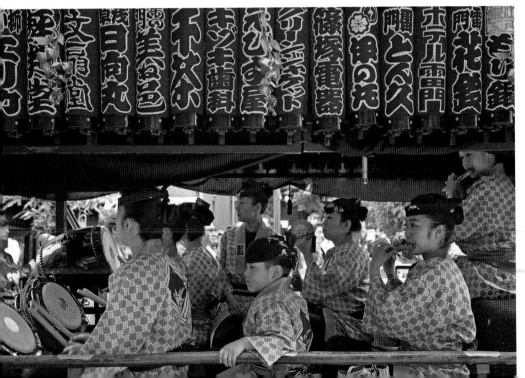

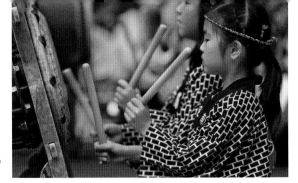

Left A neighborhood *mikoshi* portable shrine readied for action.

Below Junior wandering pilgrims in Pikachu and Mickey Mouse T-shirts.

Left Young drummers set the pace for folk dancing.

Below A petite princess at Jodo-ji Temple's 500-year anniversary.

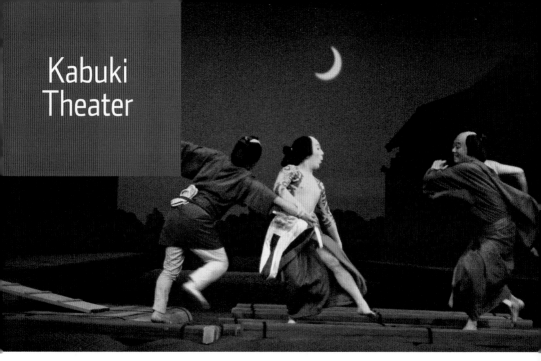

Kabuki Theater

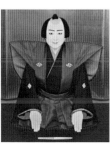

Kabuki-za is Tokyo's principal venue for kabuki, the traditional Japanese performing art that is registered by UNESCO as part of Japan's Intangible Cultural Heritage. From the original wooden theater built in 1889, the Kabuki-za has repeatedly risen, phoenix-like, from the destruction wrought by fires, earthquakes, war, and land prices. The present metamorphosis by architect Kengo Kuma retains a baroque architectural design for the theater's facade, backed by a soaring business center, Kabuki-za Tower, on the posh Ginza real estate. The new Kabuki-za has shops and ticketing downstairs, with a direct connection to Ginza's sub-

Left Dramatic action on Kabuki-za's revolving stage.

Opposite below A striking poster of a kabuki actor respectfully greets visitors at Kabuki-za.

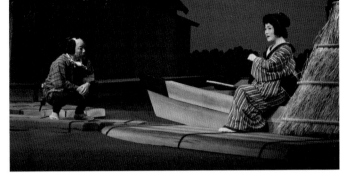

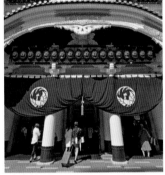

Left The main entrance of Kabuki-za Theater in Ginza.

Below A display of stage costumes in the Kabuki-za gallery.

Above A pensive moment during a lengthy performance.

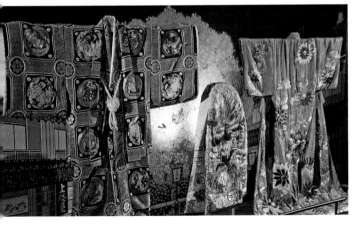

way station and a rooftop garden with a gallery of exhibits related to kabuki.

A small orchestra of traditional instruments accompanies Kabuki-za's dramatic kabuki performances, with all roles played by men since the Edo era. The 3- or 4-act plays of beloved historical dramas on a large revolving stage last an entire afternoon or evening, though single act tickets are available. Kabuki's vocal expression is so emphatic that the intent is often clear without understanding the actual archaic language. To emerge from the subway in front of Kabuki-za at twilight, with all of the colorful banners and the theater-goers in their finest beneath the strikingly lit facade, is a special drama of its own.

Sumo
Wrestling

Left Wrestlers arrive at Kokugikan Arena, impeccably robed and traditionally coiffed.

Below The ceremonial entrance of top division combatants on the sacred *dohyo* ring.

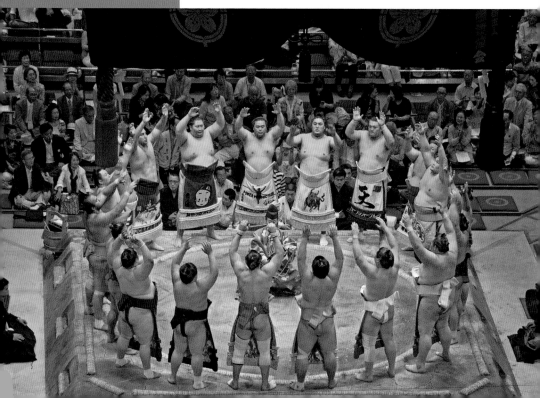

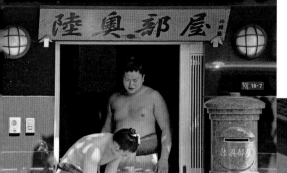

Left Young wrestlers cool down after practice at their Ryogoku sumo stable.

Below A sumo behemoth in a cute anime design kimono.

The first sumo hall at Ryogoku, near the Sumida River, was built in 1909 and christened Kokugikan, National Sport Hall, perhaps retroactively declaring the ancient martial art dating back 1,500 years as Japan's national sport. The Ryogoku Sumo Hall is the center of the Japanese sumo world, hosting three annual tournaments and surrounded by sumo stables where wrestlers live and train, and neighborhood *chanko-nabe* restaurants serving the hot pot stew of vegetables, seafood, and meat that is the staple diet of sumo wrestlers.

Below The stadium's drum tower looms above the colorful banners of a Grand Sumo Tournament.

Each long day of a two-week Grand Sumo Tournament starts early in the morning with a queue for the last tickets to the uppermost row of seats that encircle the arena. A Japanese drummer ascends the drum tower out front and plays

until the main doors open. Under a shrine-like roof in the center of the massive hall, the sumo *dohyo* ring of carefully swept sand-covered clay is considered sacred, and spectators are forbidden from approaching too closely. As matches proceed, the wrestlers are bigger, the seats fill up, and the excitement builds as the higher-ranking giants appear in the *dohyo*. Fans sitting on *zabuton* cushions in the more expensive box seats are admonished not to throw cushions when their favorite wrestler is victorious, but *zabuton* fly nonetheless.

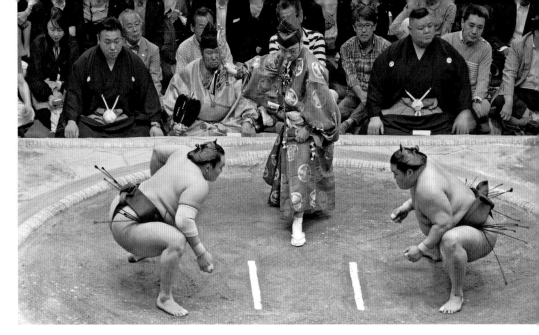

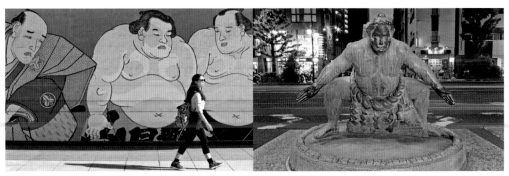

Left A *gyoji* referee in a traditional silk costume oversees the ritualized sumo bout's dramatic beginning.

Below Matches can be surprisingly swift or grind on to complete exhaustion.

Far left Large murals decorate the Kokugikan's courtyard.

Left A bronze statue of a Yokozuna Grand Champion on Kokugikan-dori Avenue.

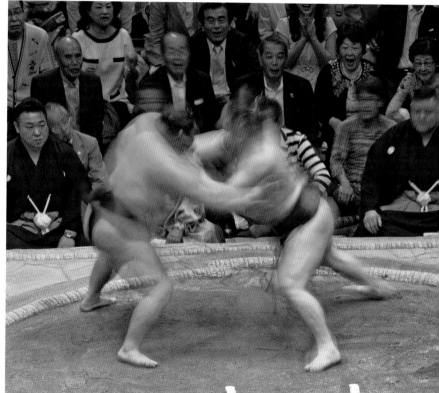

Tokyoites

Tokyoites are always in a hurry. Whether heading to work or to meet friends for dinner, Tokyoites regularly quickstep and will often break into a full run. On escalators in Tokyo's train stations, the accepted rule is that those who want to just ride should stand on the left, leaving the right side clear as an express lane for those in a hurry. City officials are pushing a "safety and manners" campaign that urges everyone on escalators to stand still, side-by-side, in two columns. These bureaucrats do not know Tokyoites very well.

The irrepressible energy that propels Tokyoites is constantly replenished by the influx of migrants that quickly become just as incredibly impatient and judgmental as their more veteran counterparts. Nothing

Above A rickshaw driver captures a newlywed memory at Senso-ji Temple's Nitenmon Gate.

Top A swirl of pedestrians and smartphones in Akihabara.

irks a Tokyoite more than detecting a whiff of disdain from Kyotoites, who have many more centuries of superiority under their belts in Japan's ancient capital. Yet, Tokyo's citizens can be amazingly patient and wonderfully tolerant, living so closely together with an inspiring grace that makes their metropolis the most civilized of cities.

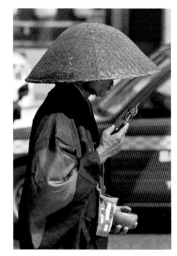

Left A family outing in Nihonbashi.

Right A Buddhist monk seeks any leftover alms from shoppers in Ginza.

Below A dedicated yoga instructor illuminated by natural light in Ogikubo.

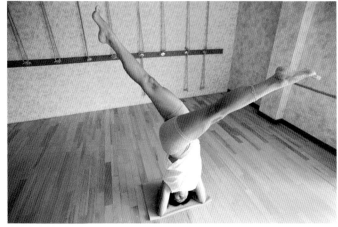

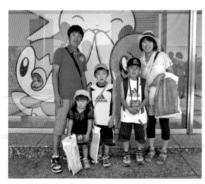

Above Waiting for friends at the National Art Center.

Right A family portrait with a Pokemon backdrop.

Above center Roppongi residents change gears after sundown.

Above right People watching and cherry blossom viewing along the Meguro River.

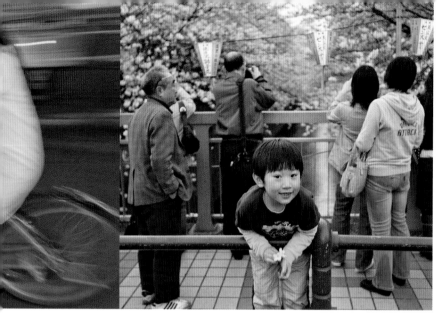

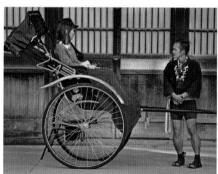

Below, left to right
A part-time pub worker in Urayasu; An amateur photographer trio take a break from shooting in Asakusa; A Sumida rickshaw driver enlightens passengers at Ushijima Shrine; A tiny new addition to the Nakameguro neighborhood.

Tokyo Style

Fashion trends come and go quickly in Tokyo, and the city's style flows with changes that brighten a backdrop of standard work "uniforms" such as business suits and women's office wear. Every year and most seasons it seems a new style hits suddenly, spreading throughout the city. One winter it might be tall

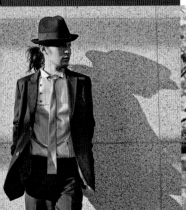

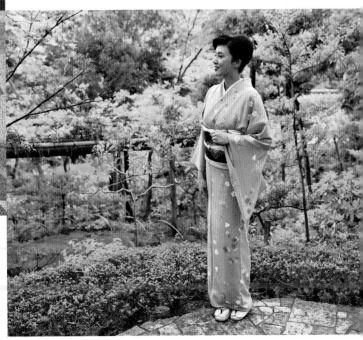

Above A sleekly stylish outfit by young award-winning designer Tomoyo Yasuda.

Top A nonchalant diva gets some serious attention at an Azabu beauty salon.

leather boots for young women, while another year brings elaborate hairstyles for young men (directly from manga or vice versa). Most styles won't survive into the following year, though women's black tights seem to be a Tokyo exception.

"Only in Tokyo could black become the color of everyday life:

graphic, modest, poignant, abstract, rich and anonymous at the same time," posited German filmmaker Wim Wenders. Classic black continues to dominate, but Tokyo style is all encompassing, so today it's no surprise to meet a fellow in bright bell-bottoms or a happy young lady colored orange from hair to heels.

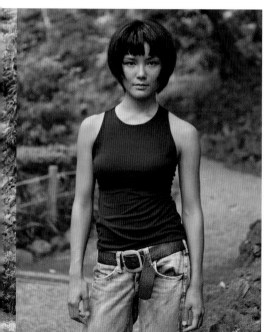

Right This demure duo have been outfitted by Chanel.

Below right A colorful fairytale Lolita waits for her train at Shinjuku Station.

Center left Nothing beats an elegant silk kimono amidst the wisteria of a spring garden.

Left Hot summer casual that Levi Strauss could never have imagined.

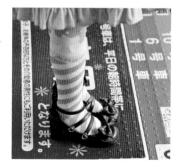

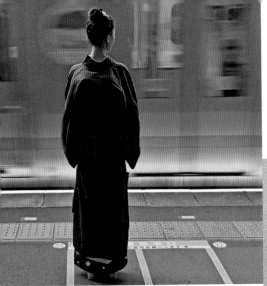

Tokyo style does require a uniform to fit every job, every outing, every hobby, a complete outfit that is perfect to the last detail of beret, hiking trousers, or white gloves, always with an umbrella ready at the slightest hint of rain.

Below A pause for consultation and a minor touch-up in Roppongi.

Above A haiku moment of perfection on the express platform at Hashimoto Station.

Right Sartorial chic accented with just a touch of impatience on the commuter platform at Tokyo Station.

Far right Pink can be a lifestyle.

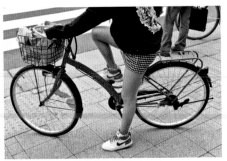

Left Coffee shop mavens.

Below Stylish juxtaposition at Meiji Shrine.

35

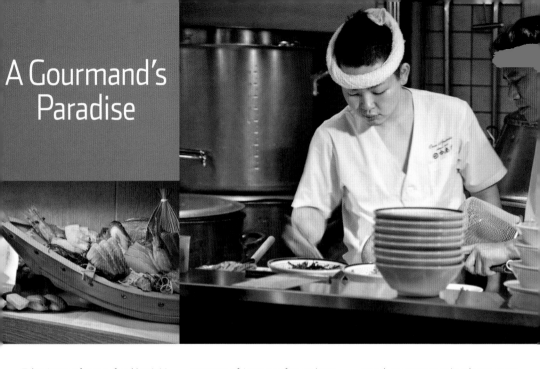

A Gourmand's Paradise

Tokyo's most famous food is *nigiri-zushi*, known worldwide as sushi. The city was still called Edo when the first chef topped vinegared rice with fresh seafood morsels from the bay. Sushi is available now at conveyor belt counters, in small shops near the fish market, or at luxuriously sparse sushi bars. Tokyo is permeated with restaurants for any type of Japanese fare or international cuisine. On Tokyo's streets, pizza delivery motorbikes compete with bicycle delivery men balancing trays of Japanese dishes on their shoulders.

Tokyo has many specialty restaurants where menus might be rice omelet variations or only *gyoza* dumplings. *Tachi-gui* shops, for stand-up customers in a hurry, serve ramen Chinese-style noodle soup or soba with buckwheat noodles, even on train station platforms. A cook-it-yourself *yakiniku* "grilled meat" restaurant in Tokyo can be located by following the smell of sizzling meat. Restaurants serving *fugu*, a potentially deadly blowfish, often have a tank of the pufferfish

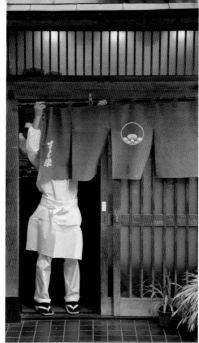

Center left A master noodle cook keeps a close watch on his young apprentice.

Left The *noren* curtain signals this sushi restaurant is open for business.

Below Succulent *ayu* sweetfish, skewered as though they are still swimming, are slowly baked over charcoal for the ultimate takeaway.

Opposite far left A display of sushi and sashimi in a boat–shaped wooden dish.

Right A rare traditional Japanese restaurant in the Roppongi nightlife district.

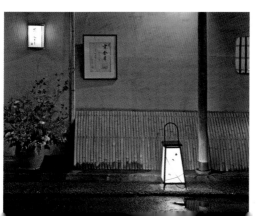

Above A giant pufferfish guards the entrance to a *fugu* restaurant.

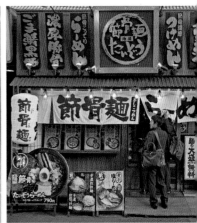

Above A restaurant with small individual grills in Akihabara.

Above center Cosplay pasta on the 54th floor of Mori Tower.

swimming out front or a wooden board covered with drying *fugu* fins to be used for *hire-zake* when lightly grilled and added to hot sake. Less esoteric eateries have plastic food displays outside to help customers choose. The ultimate in tasty, affordable Tokyo food is the *teishoku* set meal offered by many establishments, usually a hot meal with main dish, rice, miso soup, and pickled vegetables.

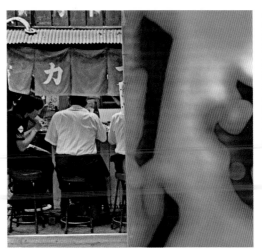

Above Students hit a ramen noodle shop after school in Ikebukuro.

Left The funky Omoide Yokocho warren of small cafés and bars at Shinjuku Station's west gate has so far resisted all modern "improvements."

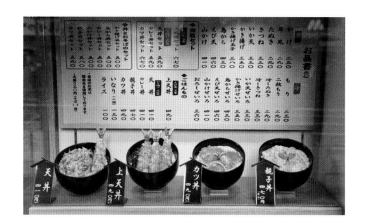

Right Helpful menu displays at a *tempura* restaurant.

Below A kitsch pneumatic noodle shop sign in Ueno.

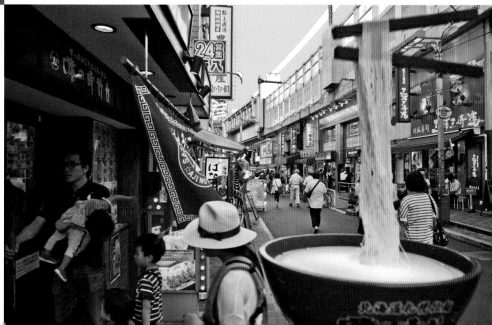

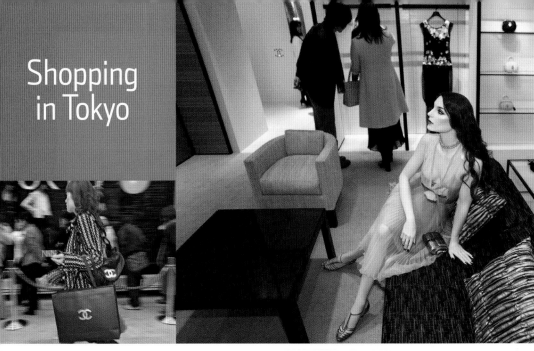

Shopping
in Tokyo

Above left A devotee rushes to the Ginza Chanel opening.

Left Hello Kitty attracts fans of all ages.

Left A quick stop at a cosmetics kiosk in Shibuya Station.

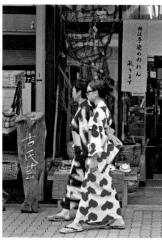

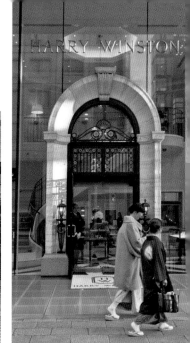

Left An option for stylish lounging between critical fashion decisions.

Tokyo has major shopping districts in Akihabara, Shibuya, Shinjuku, and Ginza, but the entire city is truly shopping-centric, if not obsessed with shopping. Young Tokyoites grow up shopping, with groups of boys and girls dedicated to serious all-day shopping. Some neighborhoods in the city have specific shopping reputations, such as Kappabashi, with its 170 shops specializing in restaurant equipment, professional kitchenware, Japanese ceramic dishes, and those plastic food displays seen outside Tokyo restaurants. Ueno's Ameyoko public market is known for a festive atmosphere and low prices on everything from bananas to blue jeans, while the other side of Ueno Station has the city's largest concentration of motorcycle shops.

Above left A couple in summer kimono promenade in the Kappabashi shopping district.

Above Winter kimono outside Harry Winston in Ginza.

Lately, oversize tour buses are blocking Tokyo streets with international shopping groups, and Chinese tourists set a fierce pace for Tokyo shopping with *bakugai* "explosive sprees," spending more than twice the amount of any other foreign shopper. The city is renowned for genuine brands, consistent high quality, and safe products. Whatever a consumer's heart might desire, whether it's cosmetics, perfume, medicine, baby care products, supplements, electronics, clothes, bags, shoes, or whatever, it can definitely be found somewhere in Tokyo.

Right Uniqlo's reasonably priced clothing revolution marches on.

Below Even this spacious shop cannot contain all of Hello Kitty's endless product line.

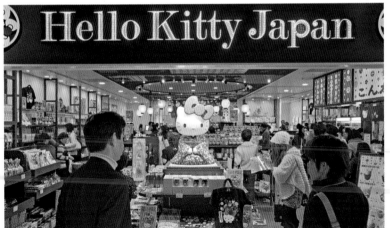

Above An Akihabara flea market is *otaku* catnip.

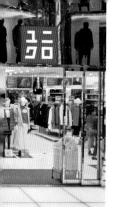

Left Tokyo's friendliest shopkeeper sells traditional Japanese toys on Edo Shiryokan-dori Street in Fukagawa.

Right Bagpipes and a drummer herald a special sale at Mitsukoshi Department Store.

Right An open-air temple market adds to festivities celebrating Buddha's birthday.

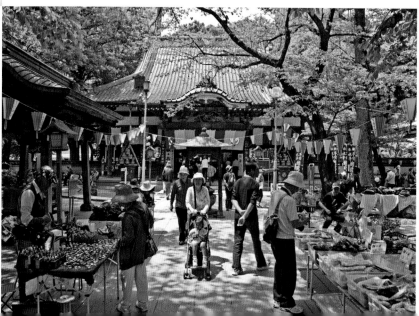

CHAPTER 2

TRADITIONAL TOKYO

Tokyo, the world's largest metropolis, grew from humble origins on the alluvial plain at the mouth of the Sumida River in a small seashore fishing village known as Edo in the late 12th century. Chosen by Tokugawa Ieyasu for his shogunate capital in 1590, Edo grew into a beautiful city built almost entirely of wood as the shogun's *daimyo* lords established huge manors, often with formal pleasure gardens. Each of the several hundred *daimyo* was required to maintain an Edo residence where his family was permanently installed to instill loyalty. A member of the British Legation to Japan in 1868 described Edo as "one of the handsomest cities in the Far East," just before it was officially declared the new Eastern Capital, Tokyo.

The *daimyo* estate gardens are a precious legacy that survive as some of the finest traditional gardens in the contemporary city, physically connecting modern-day Tokyo with its Edo-era past. Tokyo's Imperial Palace is another Edo link at the very center of the city, built upon the site of Edo Castle, which was originally designed by the multi-talented samurai architect Ota Dokan, and greatly expanded into an extensive fortress by the Tokugawa shoguns. Other traces of Tokyo's Edo legacy can still be discovered amidst the modern city's maze-like density, and even at the outskirts of a metropolis that often seems more dedicated to impermanence. A leading Tokyo taxi firm plans to help, introducing a "Virtual Edo Tour" using GPS-linked tablet computers for passengers to visualize how the city area they're driving through might have appeared back in the Edo days.

Senso-ji, with a history dating to 628, is Tokyo's oldest temple.

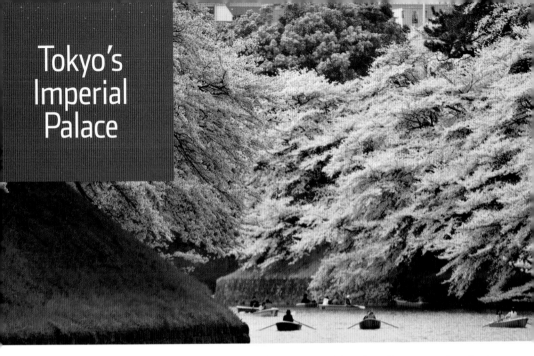

Tokyo's Imperial Palace

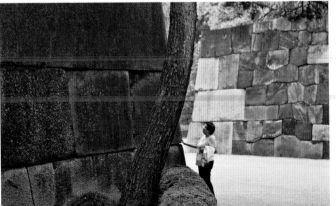

Above Cherry trees in full blossom encircle Chidorigafuchi, the palace's northeastern moat.

Left A visitor examines the massive stones of a defensive wall in the East Gardens.

Opposite above Nijubashi Bridge and the original Fushimi Yagura Watchtower at dawn.

Opposite below left A swan glides through the inner moat between steep stonewalls near Sakuradamon Gate.

In the 15th century, the warrior-poet Ota Dokan employed his architectural skills to create Edo Castle, building upon earlier Edo clan fortifications, greatly strengthening embankments and enlarging an extensive system of protective moats. Dokan's castle became the stronghold and eventual government center of shogun Tokugawa Ieyasu to rule his Kanto clan holdings. Edo Castle was expanded with "cyclopean walls" of stone, staggered defensive gates, and stables, with thousands of servants and thousands of soldiers as it grew to become the shogunate capital of Japan.

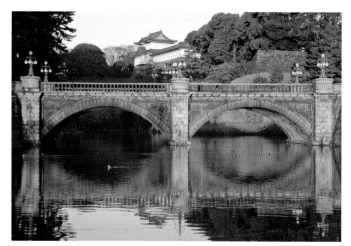

All of the shogunate inhabitants were summarily evicted upon the transfer of Imperial power, including the young Emperor Meiji himself, from Kyoto in 1868. Edo became Tokyo, the Eastern Capital, and Edo Castle the city's new Imperial Palace. As writer Donald Richie pointed out in describing Tokyo's history, "The centre of the city still proclaims its origins. There sits the Imperial Palace, ubiquitous, directly in the centre, built on the site of Edo Castle." Several of the original Edo Castle turrets from the inner citadel survive at the palace, which is the green

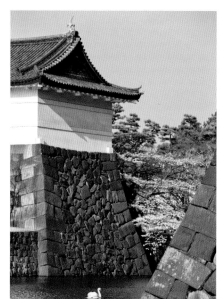

Above A vintage *kinshaki* roof finial. The tiger-headed dolphin is a talisman against fire.

heart of the modern city. The Tokyo Imperial Palace's restricted interior is the exclusive residence of the Imperial Family, but its perimeter of moats and gardens is a delightful refuge for wildlife, joggers, and visitors seeking remnants of Edo legacy or just hoping to enjoy the cherry blossoms on the vast 52 hectare grounds.

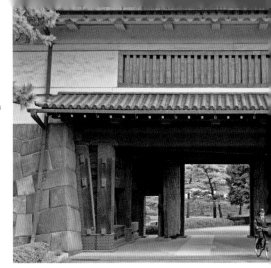

Right Hirakawamon Gate is an entrance to the palace's East Gardens.

Below An ageless tableau brushed with wind-blown white.

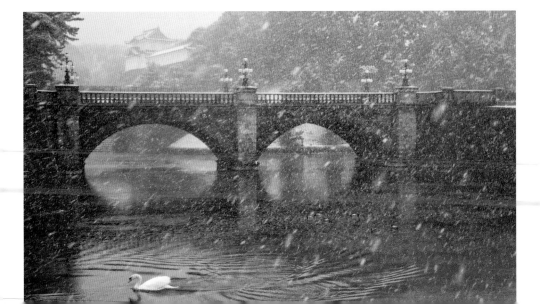

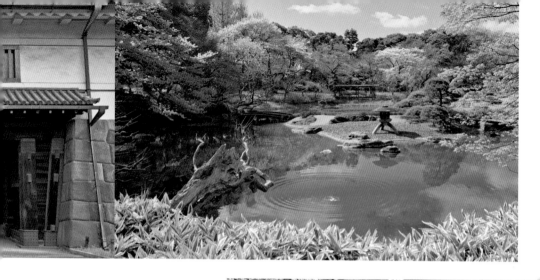

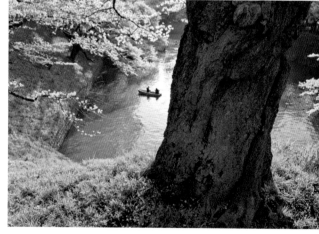

Above The Imperial Palace's Ninomaru Garden is an exquisite Japanese strolling garden.

Right The palace moat's romantic spring setting has occasionally inspired onboard marriage proposals.

Asakusa

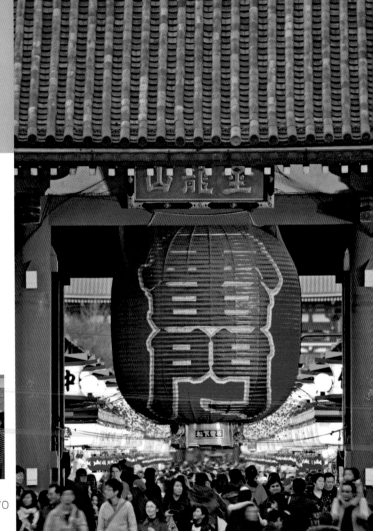

Located on the west bank of the Sumida River, Asakusa has been a destination and pilgrimage since long before the Edo period, with visitors drawn to the Asakusa Kannon Senso-ji Temple. Senso-ji is Tokyo's oldest temple, founded in 645 to enshrine the golden Kannon statue that legendary fisherman brothers pulled from the nearby river. The Nakamise-dori shopping street

leads contemporary tourists from Kaminari-mon "Thunder Gate," with its scowling guardian deities and giant *chochin* paper lantern, straight to Senso-ji's temple halls and elegant five-story pagoda. The adjacent Asakusa Shrine is an original Edo shrine that hosts the annual Sanja Matsuri, modern Tokyo's most exciting traditional festival.

At first located outside what respected historian Edward Seidensticker described as Edo's initial *Shitamachi* "Low City" mercantile district, Asakusa grew to become the city's Edo pleasure park for

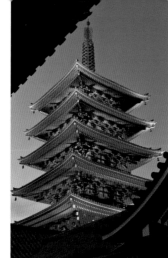

Left Senso-ji's pagoda of spiritual grace and architectural beauty is a National Treasure.

Below Kannondo's massive doors serve as a backdrop for photos.

Below left In the early morning, Kannon-do Hall, another of Senso-ji's National Treasures, is just a quiet neighborhood temple.

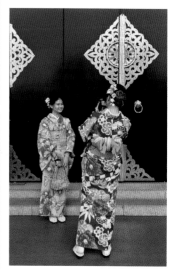

Opposite far left Healing incense smoke fills the central courtyard at Senso-ji.

Opposite right A river of humanity flows beneath the huge *chochin* paper lantern of "Thunder Gate."

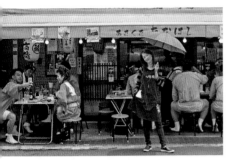

entertainments of every description. The Ginza Line, Tokyo's first subway train, reached Asakusa in 1927, helping to boost the venerable entertainment district. The Ginza Line still ends at Asakusa, its age evident not only by the vintage sound of its trains and its lower station ceilings, but by its shallow depth. Tokyo's newer subways are constructed

Far left Customers in festival attire blend in perfectly at this neighborhood pub.

Below left Consulting *O-mikuji* fortunes at Senso-ji Temple.

Below Throngs of visitors fill the temple courtyard, flocks of pigeons fill the sky.

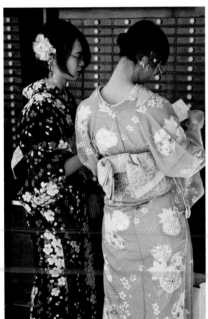

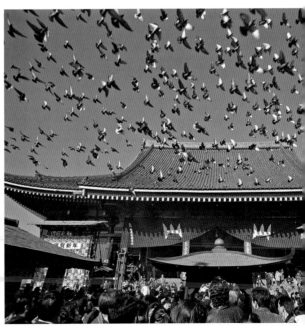

deeper and deeper underground in order to pass beneath the original routes. The modern development of western Tokyo may have dimmed the eastern Edo attractions of Asakusa, but the towering Tokyo Skytree's appearance just across the river is rejuvenating the area, summoning fresh troves of visitors by both subway and water bus.

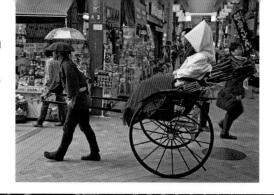

Right A newlywed couple savor a rickshaw ride through Asakusa's lively network of shopping streets.

Below Offerings made, hands clapped, wishes intoned.

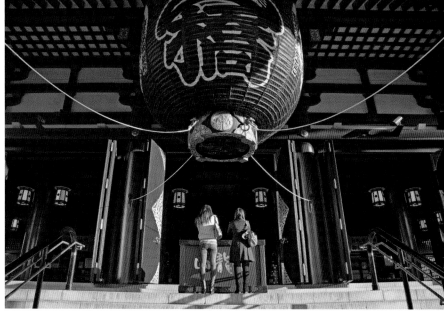

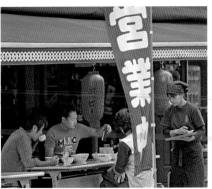

Above A peek beneath a giant *chochin* lantern at Hozomon Gate reveals a carved wooden dragon.

Left An open-air restaurant specializing in noodles and *gyoza* dumplings.

Right Waentei Kikko is one of many traditional restaurants on the back streets of the temple district.

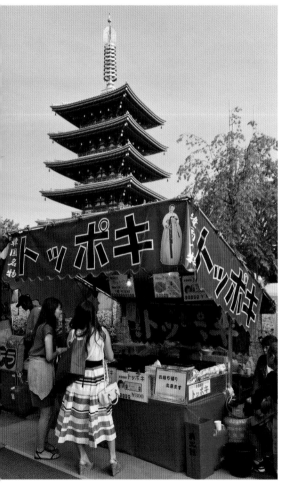

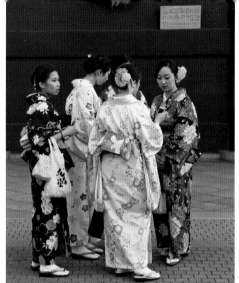

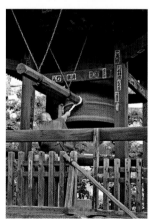

Above A pretty covey of young women in *yukata* summer kimono regroup by Hozomon Gate.

Far left *Yatai* food carts and the five-story Goju-no-to Pagoda.

Left A Buddhist priest strikes the "Bell of Time." The bronze bell, cast in 1692, was the subject of a haiku by Matsuo Basho.

Shibamata Temple Town

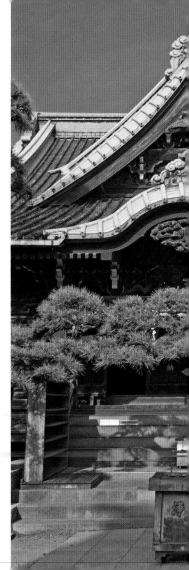

An Edo-period temple town, Shibamata is located at the far northeastern edge of the city along the west bank of the Edo River. The shogunate's Yagiri-no-Watashi ferry landing still operates in Shibamata, with traditional wooden oar boats (now with outboard motors for emergencies) taking passengers across the broad river to the once remote hinterlands of Chiba. The Shibamata Taishakuten, a Nichiren Buddhist temple dating to 1629, is arguably Tokyo's most beautiful temple. Nitenmon Gate frames the temple's entrance with exquisite wooden carvings, and hand-carved wooden relief panels depicting the Lotus Sutra are beautifully integrated in the exterior walls of the Naiden Prayer Hall. The Naiden's gallery of amazingly detailed relief sculptures, executed on individual slabs of zelkova wood, is connected by covered walkways that completely encircle the temple's large, carefully tended garden.

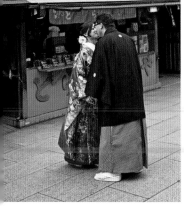

Left Newlyweds pause for a memorial kiss on Taishakuten-Sando, the shopping street leading to Shibamata Taishakuten.

Right The "Lucky Dragon" pine tree stretches across the entrance of Taishaku-do Hall.

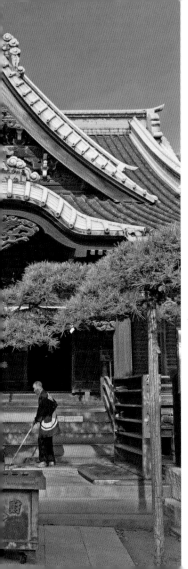

Right A young boatman rows the small wooden ferry with a single oar across the Edo River at historic Yagiri-no-Watashi ferry crossing.

Below A guest pavilion overlooks Suikei-en, a traditional Japanese garden at Shibamata Taishakuten Temple.

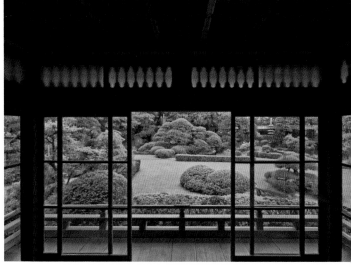

Shibamata is also popularly known as the hometown of Tora-san, the cinematic hero of the venerable film series "Otoko wa Tsurai yo" (It's Tough Being a Man), played by Kiyoshi Atsumi from 1969 until 1995. A Tora-san Museum with displays and sets from the films was recently opened in Shibamata Park near the river. The Taishakuten-Sando shopping street leads from the namesake temple to a bronze statue of Tora-san with his iconic leather suitcase in hand, which stands outside the small Shibamata train station where the character often fled life's irksome responsibilities to return to his itinerant peddler's lifestyle during many of the 48 movies in the series.

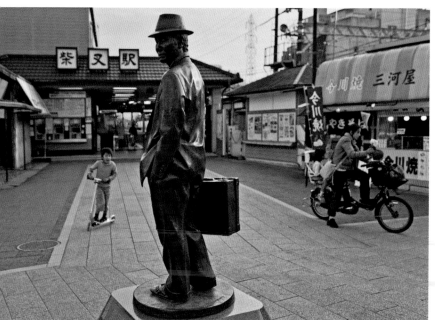

Above A classic head shot of Tora-san, famous itinerant peddler-philosopher of the Japanese cinema.

Left A bronze statue of Tora-san stands in front of Shibamata Station, where the movie character often fled from responsibilities and heartbreak.

Right Nitenmon Gate, with its beautiful carvings, is constructed of *keyaki*, Japanese zelkova wood.

Left An elegantly simple stone *tsukubai* water basin on a rocky hillside in Suikei-en Garden.

Right A young cook grills chicken *yakitori* at a Japanese pub near Shibamata Station.

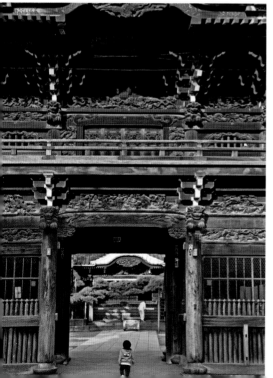

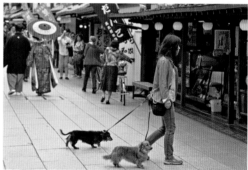

Above Shops line Taishakuten-Sando, the approach street leading from Shibamata Station to Shibamata Taishakuten Temple.

Left Tora-san's iconic valise, hat and cummerbund from the popular "It's Tough Being a Man" film series are displayed at the Tora-san Museum.

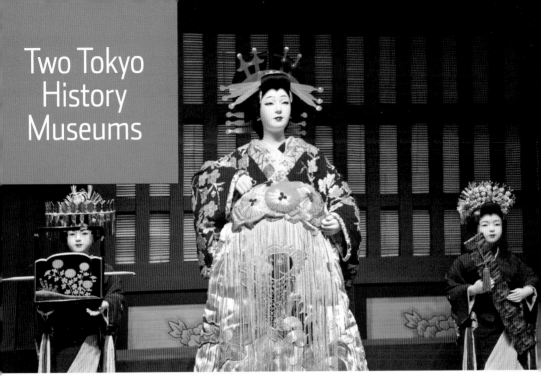

Two Tokyo History Museums

Above A kabuki display in the Theatres and Pleasure Quarters section of the Edo Zone at the Edo-Tokyo Museum.

Left A morning field trip for students to the museum.

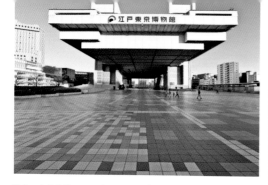

Below left A fine wooden statue of shogun Tokugawa Ieyasu, who supervised the construction of Edo Castle, is fittingly displayed in the Edo Castle Zone of the museum.

Above The spacious Edo-Tokyo Terrace showcases the monumental architectural style of the Edo-Tokyo Museum.

Below A display of a costumed kabuki actor inside the Edo-Tokyo Museum.

Bottom Visitors can try lifting and balancing a vendor's shoulder pole in the Commerce of Edo section of the Edo-Tokyo Museum.

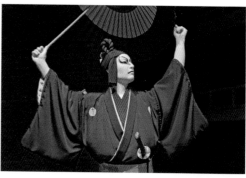

The Edo-Tokyo Museum is located adjacent to the Ryogoku Sumo Hall near the Sumida River in the east bank Sumida district of Tokyo's old downtown *shitamachi*. Despite its modern architectural exterior, the museum chronicles the history of Tokyo dating back to the Edo period. From an expansive tiled plaza with fine views of Tokyo Skytree a bit further north, a futuristic red escalator tube carries visitors up into the huge mothership-like museum building. Exhibits and attractions within the vast interior space include a full-size wooden replica of the original

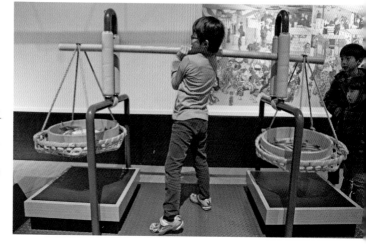

TRADITIONAL TOKYO 61

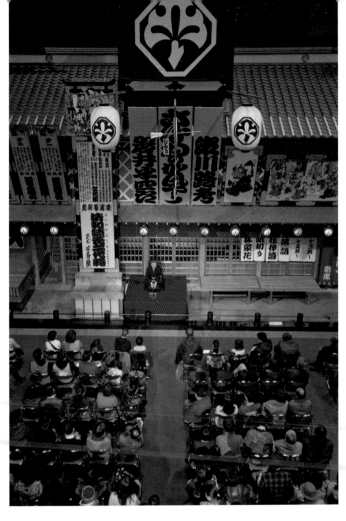

Edo-era Nihonbashi Bridge and a reconstruction of the Nakamura-za Kabuki Theater that presents live vaudeville-style entertainments and *rakugo* storytellers.

The Sumida Hokusai Museum is just a short walk due east from the Edo-Tokyo Museum. Dedicated to the work and life of Edo's greatest artist, Katsushika Hokusai, who was born nearby in 1760, the shiny new museum was designed by Pritzker Prize-winning architect Kazuyo Sejima. A renowned *ukiyo-e* woodblock master, Hokusai's influence was far-reaching, inspiring even European artists such as Vincent van Gogh. The adjacent Midoricho Park attracts neighborhood kids each afternoon. The local children celebrate like it's special recess time right in front of Hokusai's museum: kickball, tag, jungle gyms, swing sets, skateboards, and happy screams. No finer *shitamachi* scene can be found anywhere in the city.

Left A *rakugo* story-teller performs at the Nakamura-za Kabuki Theater inside the cavernous Edo-Tokyo Museum.

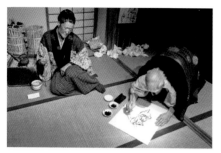

Above left A re-creation of Hokusai's art studio with animatronic models of the artist and his daughter Oei at the Sumida Hokusai Museum.

Above Students savor a sunny lunch break outside the Edo-Tokyo Museum.

Left A neighborhood park melds seamlessly with the subtly reflective facade of the Sumida Hokusai Museum, dedicated to the renowned Edo-era woodblock artist and favorite son, Katsushika Hokusai.

The Bridge of Japan

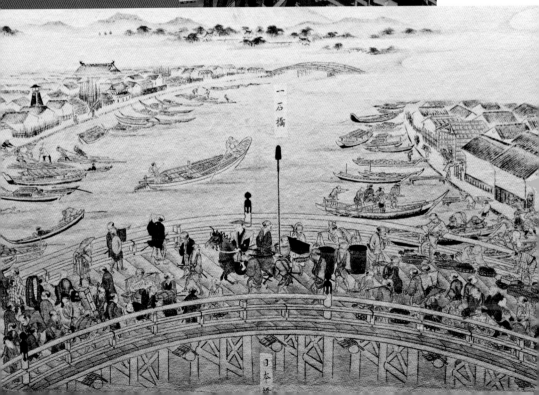

一石橋

日本橋

Modern Nihonbashi is a bridge, a river, and a prosperous financial and commercial district that includes Bank of Japan's headquarters and the vibrant Mitsukoshi Nihonbashi, Japan's first department store. The original Nihonbashi, meaning "Bridge of Japan," was a wooden bridge built in 1603 across a re-channeled river taking the same name as the mercantile neighborhood also known as Nihonbashi. Historian Edward Seidensticker insisted, "The heart of the Low City was Nihonbashi, broadest of the lands first reclaimed by the shogunate." Japan's most famous bridge, Nihonbashi, was the eastern terminus of the inland Nakasendo and the coastal Tokaido roads running between Edo and the Imperial capital of Kyoto.

Nihonbashi Bridge marked the zero point from which all road distances were measured. The current Nihonbashi Bridge of stone and steel dates to 1911. Its ornamental sculptures include dragon-like creatures that are actually mythical *kirin*, an auspicious chimerical beast. Unfortunately, a portion of the Shuto Expressway was built directly over the bridge and river course during rushed modernization efforts before the 1964 Tokyo Summer Olympics. Rumor has it that the highway is scheduled to be rerouted in the near future so that the classic bridge will once again be open to the sky above.

Opposite below A detailed historical scroll depicts the arched wooden Nihonbashi Bridge of Edo in 1805.

Above left Afternoon sunlight casts shadows on the stone balustrade of the venerable Nihonbashi Bridge, with an unfortunate elevated expressway hovering overhead.

Above right Jet skis in the Nihonbashi River zip underneath Nihonbashi Bridge.

Above A mythological dragon-like *kirin* statue on Nihonbashi Bridge.

Two Historic Gardens

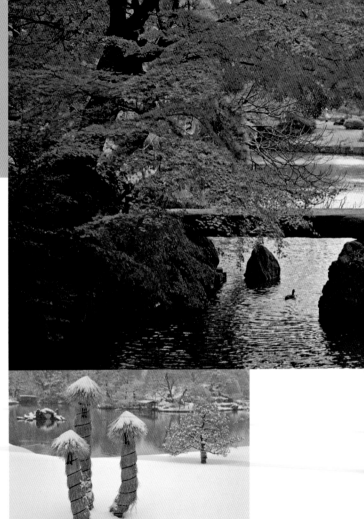

Above Green tea and a winter sweet served on a lacquerware tray at Rikugien's Fukiage-chaya Teahouse.

Above right Togetsukyo Bridge is constructed of two huge stone slabs.

Right The sculptural shape of protective *wara-maki* straw coverings at Rikugien is accentuated by snow.

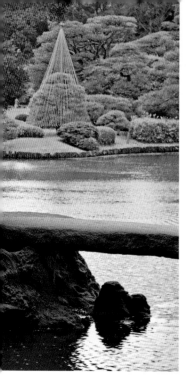

In the northern wards of Tokyo's upland *Yamanote* "High City," the Komagome area boasts two of the city's most beautiful gardens. Rikugien is an Edo-era *daimyo* estate garden located to the east of Komagome Station, and to the west Kyu-Furukawa Teien mixes Western and Japanese-style gardens. Rikugien Garden is considered a perfect example of formal landscape gardens of the Edo period (1603–1868). The shogunate deeded the land in 1695 to the Lord of Kawagoe, who constructed Rikugien (Garden of Six Principles of Poetry) to reflect his love of classical *waka* poetry. The *kaiyu* circuit-style garden encompasses man-made hills and ponds, a teahouse pavilion crafted of azalea wood, and a strikingly simple bridge made of two massive stone slabs.

Far right Roses bloom in the Western-style villa's garden at Kyu-Furukawa Teien.

Above right Abstract autumn leaves revolve around the shapely limbs of a Japanese maple tree on a stormy afternoon at Rikugien Garden.

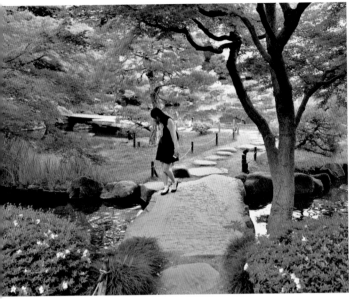

Rikugien is a garden of refined beauty and birdsong in every season.

Kyu-Furukawa Gardens are built on a steep slope of the Musashino Plateau tableland. The upper garden features a stone mansion and rose garden designed by influential British architect Josiah Conder in 1917. Isolated below by thick woodland is an outstanding Japanese garden built by Ogawa Jihei VII, a renowned garden architect from a venerable Kyoto family of landscape gardeners dating back many generations to before the Edo era. The casual visitor first entering the upper garden at Kyu-Furukawa might completely overlook the fine traditional garden below because of its ingenious topographic placement and landscaping.

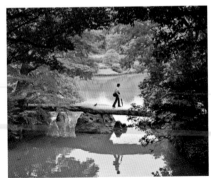

Above Azalea blossoms and a stone slab bridge in the Taisho-era garden designed by Ogawa Jihei VII at Kyu-Furukawa Teien.

Right Autumn woods surround the earth-and-log Yamakagebashi Bridge at Rikugien.

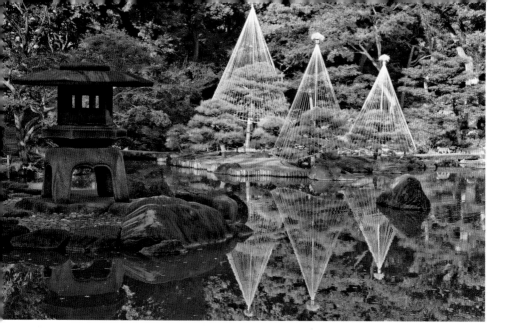

Above A resident tabby cat crosses a low stone bridge to an islet in the garden pond at Kyu-Furukawa Garden.

Left A woman and a pigeon walk across Togetsukyo Bridge at Rikugien Garden.

Right A boathouse and beautifully sculpted pine trees line the pond at Rikugien Garden.

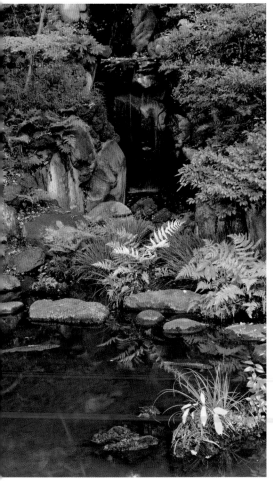

Left The Otaki Waterfall, with carp that match the first autumn foliage, at Kyu-Furukawa Teien.

Below and bottom Tsutsujichaya is an elegantly rustic Meiji-era teahouse pavilion made with azalea wood at Rikugien Garden.

Right A spring view of the Furu-kawa Toranosuke Villa, built in 1917 at Kyu-Furukawa Garden by British architect Josiah Conder.

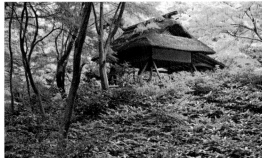

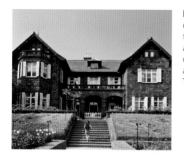

Below Mother and daughter enjoy the strolling path along the shore of Shinji-ike Pond at Kyu-Furukawa Teien.

Right A young visitor reaches the highest point of Rikugien Garden on a snowy winter morning.

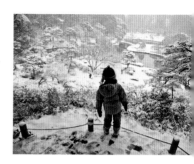

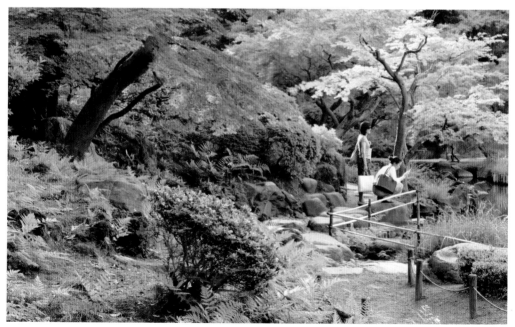

A Haiku Master's Retreat

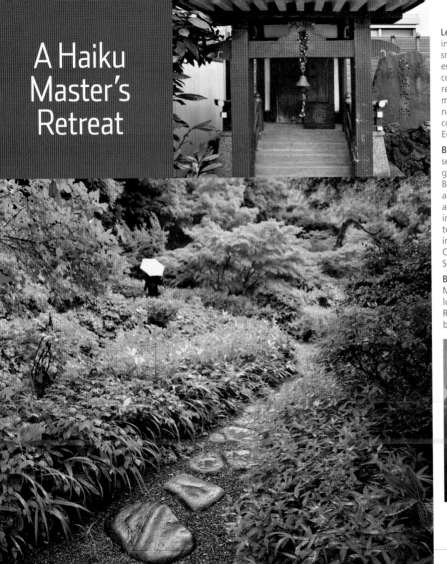

Left Basho Inari Jinja in Fukagawa is a small Shinto shrine established to commemorate the renowned Haiku master who lived nearby, in Basho-an cottage, during the Edo period.

Below left A rainy season view of the garden at Sekiguchi Basho-an Hermitage, where the aspiring poet lived in a hut from 1677 to 1680 while working on the Edogawa Canal Water Supply System.

Below A statue of Matsuo Basho overlooks the Sumida River and Kiyosubashi Bridge.

Below A stone statue of the legendary poet in a small replica thatched hut at the Basho Memorial Museum.

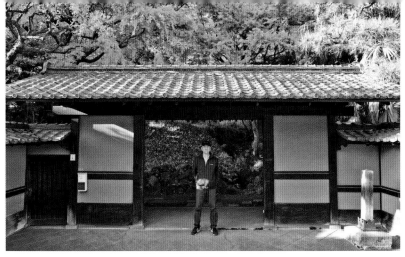

The Edo-period haiku master, Matsuo Basho, lived in Edo while perfecting his poetry, and the city was the poet's base for his most renowned travel journals. Basho's pen name was Tosei, meaning "Green Peach," when he lived in a water-watcher's hut, working as a supervisor on Edo's Kandagawa Josui waterworks for four years. The hut's location just above the clear waters of the Kanda River in the Sekiguchi neighborhood is memorialized as the Sekiguchi Basho-an Hermitage. The quiet retreat has a library pavilion open to the seasonal elements, with simple wooden tables, woven rope-and-wood chairs, and a long carved wooden bench underneath large plate glass windows that overlook the modest natural garden and its gourd-shaped pond. The director of the hermitage, Kinuta Ohba, is a Basho scholar, a poet, and a soft-spoken educator who also does the gardening. The contemplative atmosphere that Ohba-*sensei* engenders at the Basho-an garden creates the city's best spot for reflecting on the inspiration of Basho's life and work.

A patron enabled Basho's move to a more remote location on the far bank of the Sumida River in Fukagawa to concentrate on his writing in

Top If this main gate with its *kawara* tile roof at the entrance to Basho-an Hermitage is closed, try the smaller hillside gate.

Above Red-eared slider turtles sun themselves on rocks while large *koi* carp swim in the revitalized Kanda River, once a part of the Edogawa Canal Water Supply System.

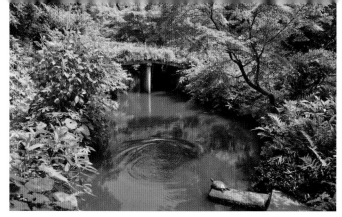

1680. His riverside residence was a thatched single-room cottage with a banana tree planted by a student in its garden. The resilient but relatively useless *basho* "banana tree" inspired the poet's famous pen name. Little remains of Edo-era Fukagawa after the city's many cycles of destruction and development, and no trace of Basho. The approximate location of the Fukagawa Basho-an cottage is marked by a small shrine built where a stone frog said to be treasured by the poet was discovered after a tsunami in 1917. The frog is now part of the collection at the nearby Basho Museum, where a compact traditional garden leads up to the Sumida River Terrace and a hilltop memorial with a bronze statue of Basho. The great Edo poet seems to gaze out over the river, and one might imagine a haiku inspiration blending nostalgic history with the modern city.

Top left A turtle watches over the Hyotan-ike garden pond at Basho-an Hermitage.

Above A gardening consultant checks on the carp in "Gourd Pond" at Sekiguchi Basho-an Hermitage.

Left Legend has it that this stone frog, discovered nearby in Fukagawa following a severe tsunami in 1917, was dear to the renowned poet.

Right A wooden statue of Basho, sculpted as a memorial in 1727, 33 years after the poet's death.

Below Stepping stones at the hillside garden entrance to Basho-an Hermitage.

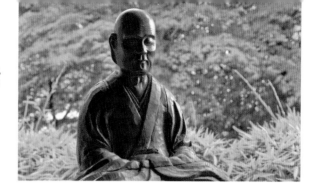

Edo-Tokyo Historical Park

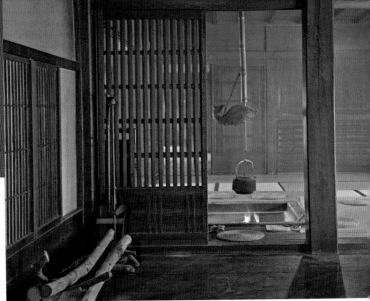

Above Sturdy *bangasa* umbrellas made of *washi* paper and split bamboo "dry" inside the Kawano Shoten Oil-paper Umbrella Store.

Above right An *irori* sunken hearth inside a thatched roof *minka* farmhouse built during the Edo era.

Right A *nagaya* gate frames a rustic farmhouse.

Known more simply in Japanese as Tatemono-en, this branch of the Edo-Tokyo Museum is located in Koganei Park in western Tokyo. Tatemono-en was established by the Tokyo Metropolitan Government in 1993 in an effort to "relocate, reconstruct, preserve and exhibit historical buildings" threatened by demolition. Traditional Japanese structures, largely wooden, have suffered greatly from fires, typhoons, earthquakes, and war since the Edo

period, but the losses continue due to Tokyo's non-stop growth and unchecked development. Increasingly restrictive building codes and fire department regulations hasten the process, frustrating Japanese carpenters as well as owners trying to maintain traditional buildings in the city.

This Edo-Tokyo collection of historic structures in an open-air landscaped park of fields, woods, and gardens is an enjoyable chance to admire some of Edo's architectural beauty and whimsy. There are also fine examples of early Meiji and Showa-period buildings. The atmosphere is especially inviting at a thatched roof farmhouse with

its working *irori* hearth, and kids will inevitably want to climb into the large empty pools of the public bathhouse. There is an excellent Edo-era bar that seems to await old neighborhood customers, and a popular re-creation of a commercial street where the displays in the dry goods and hardware shops are like an antique collector's dream.

Above Woven baskets on simple wooden shelves were for bathers' clothing at an early Showa-era public bathhouse.

Left An *engawa* veranda adds light and space to a traditional *minka* farmhouse.

Far left *Noren* curtains at the entryway of the wooden Kagiya building, a liquor shop and bar built in 1856.

Left The Showa-era Maruni Shoten kitchenware store seems ready for business.

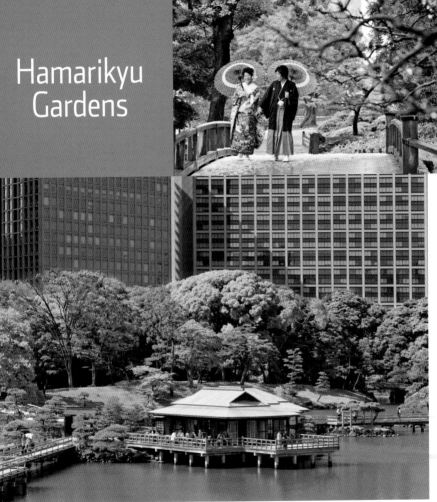

Hamarikyu Gardens

Above A light snow gives this couple a chance to try out traditional *wagasa* paper umbrellas.

Left The Nakajima Teahouse is on an islet in Shioiri-ike, Tokyo's last tidewater garden pond.

These fine public gardens near the mouth of the Sumida River were originally part of the Tokugawa shogunate's family villa during the 17th century. The garden estate was known as Hama Goten—the "Beach Palace" of the shoguns for more than a hundred years, offering aesthetic pursuits such as tea ceremonies and poetry in addition to falconry and duck hunting. After the Emperor moved to town with the Meiji Restoration, it became the Hama Detached Palace for the Imperial family. The spacious park is now one of the largest remaining Edo gardens.

Below Hama-Rikyu is a traditional *kaiyu* circuit-style garden, perfect for an afternoon stroll.

Right The Shio-dome business complex imposes contemporary *shakkei* "borrowed scenery" on the garden's landscape.

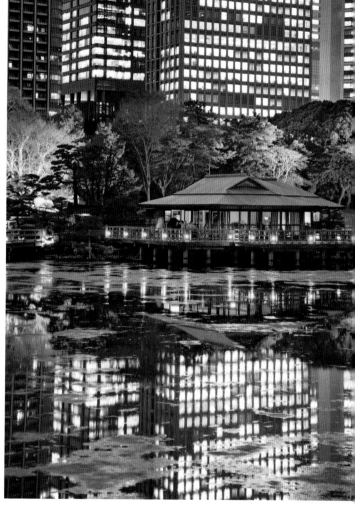

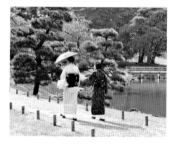

Hamarikyu centers on a classic stroll garden surrounding Shiori-ike Pond, Tokyo's last garden pond subject to the ebb and flow of tidal seawater. Saltwater fish such as black mullet and sea bass swim in Shiori-ike, with gulls and ducks paddling on its surface. There is also a peony garden, an apricot grove, and flower fields of multicolored cosmos and yellow rape. The traditional teahouse built on an island in Shiori Pond affords an excellent spot to sip *maccha* green tea and contemplate Hamarikyu's unique *shakkei* "borrowed scenery" of Shiodome business towers looming above the garden's comforting greenery.

Below A rare winter snowfall makes for a memorable date.

Right A couple stroll through a fresh spring array of ornamental pine, maple, and cherry trees.

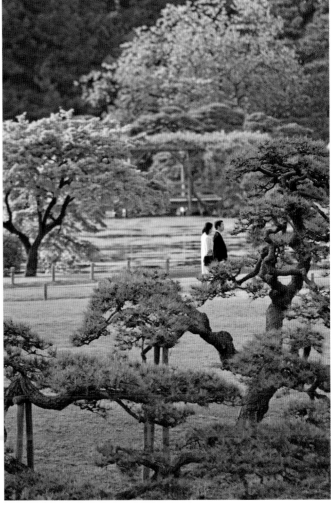

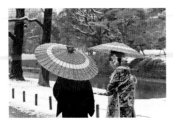

Below The newly replaced Naka-no-hashi Bridge over the tidal seawater of Shioiri Pond.

Right A couple descend stone steps on a wooded man-made hillside.

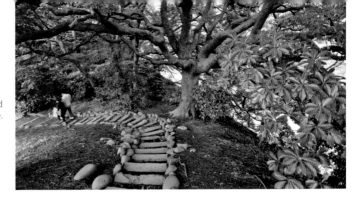

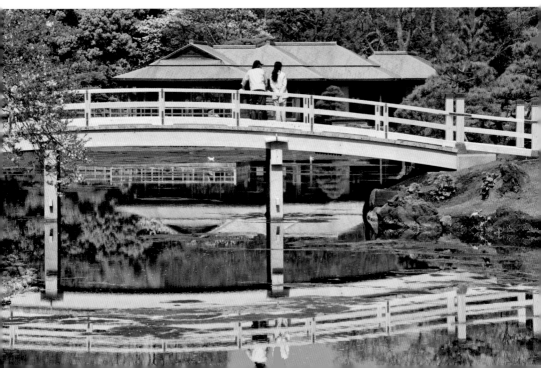

Kamakura

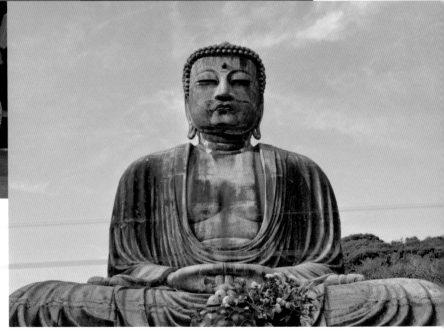

Once an ancient shogunate capital, Kamakura is situated on the coast an hour south of Tokyo, backed by steep mountains and rich with historical shrines and temples. The waves of Sagami Bay at Kamakura attract surfers where the dramatic Mt Fuji backdrop once captivated the great Edo woodblock artist, Katsushika Hokusai. Kamakura's most sacred Shinto shrine, Tsurugaoka Hachiman-gu, has an approach directly from the sea through large *torii* gates to the hillside Hongu Main Shrine. Further inland is the quieter Kamakura-gu Shrine.

Above The Moso Bamboo Garden gives Hokoku-ji its popular name, the Bamboo Temple.

Right An autumn view of Nitenmon Gate at Myohon-ji Temple.

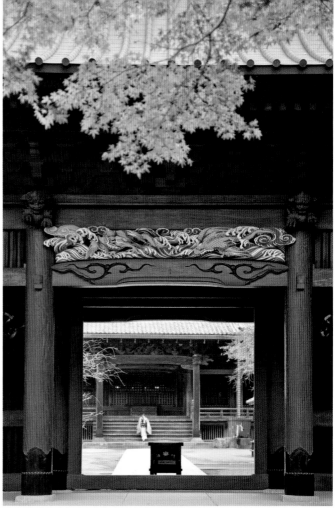

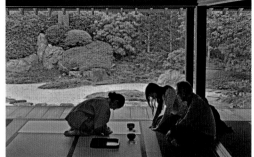

Kamakura has a Bamboo Temple (Hokoku-ji), two Hydrangea Temples (Hase-dera and Meigetsu-in) famous for their flowering gardens, and the Kamakura Gozan "Five Great Temples of Zen," which include the oldest Zen training monastery in Japan. The vintage Enoden Electric Railway from Kamakura Station is a fine way to reach the city's Daibutsu "Great Buddha," a giant 13th-century bronze-cast National Treasure that epitomizes the strength of contemplation. The Great Buddha sits placidly in the open air as each day's changing light plays across its benign countenance, as the seasons change, as centuries come and go.

Above The *kuromatsu* black pine at Hasedera's Sanmon Gate is like a perfectly shaped giant-size *bonsai*.

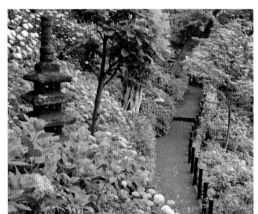

Top left Zen monks at Hase Station on the "Enoden," the 10-km Enoshima Electric Railway, founded in 1902.

Top Green tea being served by the Zen rock garden at the 12th-century Jomyo-ji Temple.

Above The winding path known as Prospect Road in the hillside hydrangea garden at Hase-dera Temple.

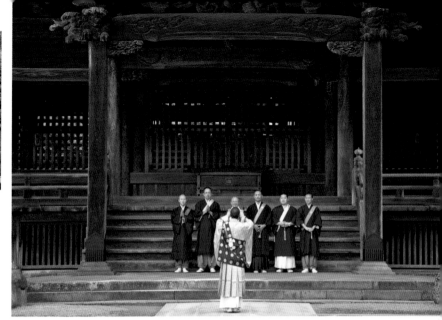

Right A group portrait of Buddhist monks at the Soshido Founding Priest's Hall of Myohon-ji Temple.

Left Engaku-ji, established in 1282, is the largest Zen temple in Kamakura.

Right Surfers in Sagami Bay have a snow-capped Mt Fuji for inspiration.

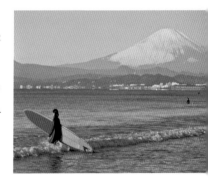

TRADITIONAL TOKYO 85

The Old Castle Town of Kawagoe

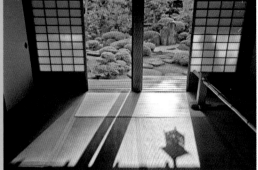

Right Life-size costumed models of a *daimyo* meeting with his vassals at Honmaru Goten Palace, the only surviving building of Kawagoe Castle.

Known affectionately as "Little Edo," the old castle town of Kawagoe is located on the western edge of the Kanto Plain about 30 kilometers northwest of central Tokyo. The renowned 15th-century samurai monk Ota Dokan was evidently a multi-tasker, constructing Kawagoe Castle in 1457 while also working on Edo Castle. Kawagoe's castle served as a strategic satellite fortress defending Edo from northern attacks. The wooden Honmaru Palace lord's residence remains as the sole surviving structure from Kawagoe Castle. Interestingly, the only original buildings from Edo Castle are also found in Kawagoe, at Kita-in, a Tendai Buddhist temple founded in 830. To support Kita-in's rebuilding after an Edo-period fire, the Tokugawa shogunate compassionately moved several Edo Castle buildings to Kawagoe for the temple's use.

Kawagoe was also a trading hub in the Edo era, connected to the city by roads and waterways, and its mercantile district once contained hundreds of traditional clay-walled *kurazukuri* storehouses. Spared serious damage during the Pacific War, several dozen original storehouses still attract shoppers and tourists

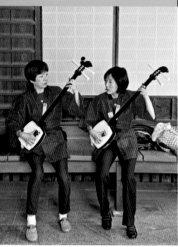

Above Musicians tune *shamisen* before their performance during the Hanamatsuri Festival at Renkei-ji Temple.

Top The Shoin Study at Kita-in Temple is an original structure from Edo Castle.

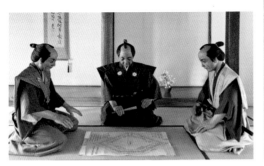

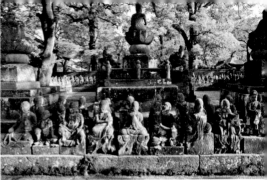

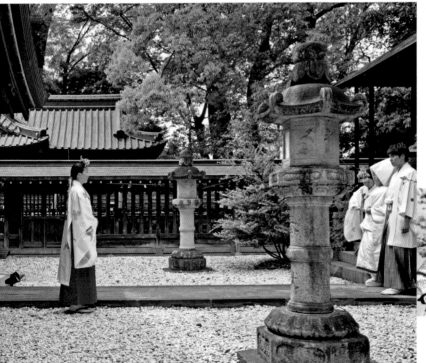

Above The 500 stone Gohyaku Rakan Disciples of Buddha statues in a courtyard garden at Kita-in Temple.

Left A Shinto wedding ceremony in the inner courtyard of Hikawa Jinja Shrine.

Below A bronze statue of Ota Dokan (1432–1486), the samurai architect builder of Edo Castle and Kawagoe Castle.

to Kawagoe. The *kurazukuri* were built on stone foundations with clay walls nearly a foot thick for security and fireproofing, and topped with sturdy *kawara* ceramic roof tiles. The oldest surviving Kawagoe *kurazukuri* was built in 1792. A young couple in traditional *yukata* summer kimono relaxing in front of a Kawagoe store-house might be as close to an Edo scene as one can imagine. It may require even greater imagination for the powers that be to someday close Kawagoe's unique "Kurazukuri Street" to motor traffic.

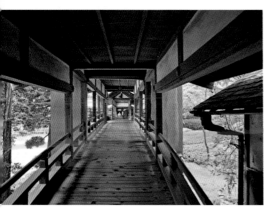

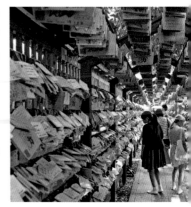

Above left Morning preparations at a shop selling pickled vegetables on Ichibangai Street in Kawagoe's Kura-zukuri Traditional Architecture Zone.

Left The long wooden *kairo* roofed corridor leading to Jikei-do Hall at Kita-in has a squeaky "nightin-gale floor" for security.

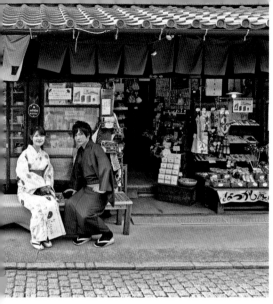

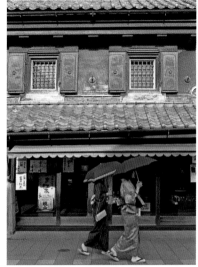

Above A young couple in summer kimono resting at a wooden *machiya* townhouse is a timeless "Little Edo" scene.

Left The unique Ema Tunnel of hanging *ema* votive tablets at Hikawa Shrine.

Above right A fire-resistant *kura* storehouse with thick clay walls and *kawara* clay tile roof, now used as a sake shop, on Ichibangai Street.

Right The Kyaku-den Reception Hall at Kita-in Temple is an original building from Edo Castle, relocated by shogun Tokugawa Iemitsu.

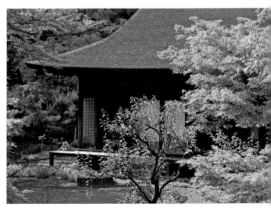

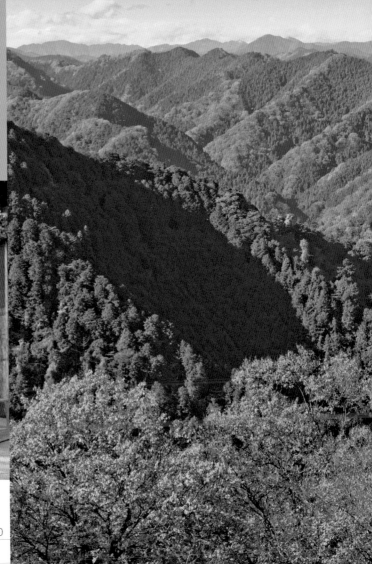

Mount
Takao

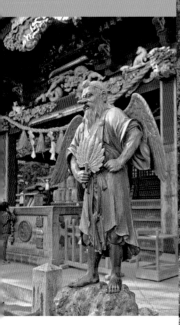

Located in Hachioji on the western edge of Metropolitan Tokyo, Mount Takao is thickly forested, including many giant Japanese cedar trees said to be 700–1,000 years old. A choice of hiking trails follows streams and natural contours leading to the 599-meter summit, though one can get halfway up by cable car. Only an hour from Tokyo proper, Mount Takao, known as Takao-san, is home to a great variety of flora and wildlife, including monkeys and wild boar. Tengu also dwell on the sacred mountain.

Tengu are protective guardians, legendary long-nosed goblins from Japanese folklore, frightening and mischievous, but Takao-san's *tengu* watch over the mountain and its forests. Hikers and pilgrims visit Mount Takao year round for fresh air and exercise but also to seek spiritual comfort at Takaosan Yakuo-in Temple with its splendid *tengu* statues. Yakuo-in was established on the mountain by Imperial order in 744 and has close ties with Shu-gendo mountain asceticism. A giant stone *tengu* on the train platform at Takao Station greets visitors arriving in the morning and watches over tired hikers leaving in the evening.

Opposite left A finely sculpted bronze Tengu at Izuna-Gongen-do Hall of Yakuo-in Temple on Mount Takao.

Opposite right Autumn view of the surrounding mountains from Takao-san, a popular hiking and pilgrimage destination an hour from central Tokyo.

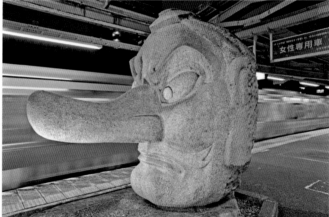

Top A lighthearted "Tengu Crossing" sign warns of mischievous mountain deities on the loose.

Left A hiking family sets off on the wide trail at the base of Mount Takao.

Above A large stone Tengu, the long-nosed protective mountain demon of a deity, watches over the train platform at Takao Station.

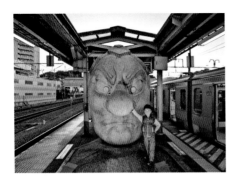

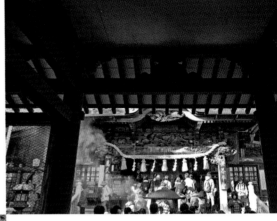

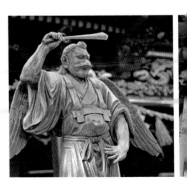

Above left A young Takao-san hiker poses with the large Tengu statue at Takao Station.

Left A *Nio* guardian statue inside Shitenno-mon Gate guards the approach to Yakuo-in.

Above Niomon Gate frames the large bronze censer with healing smoke in front of Yakuo-in's Honden main hall.

Opposite above An observatory halfway up Mount Takao offers refreshments and panoramic views.

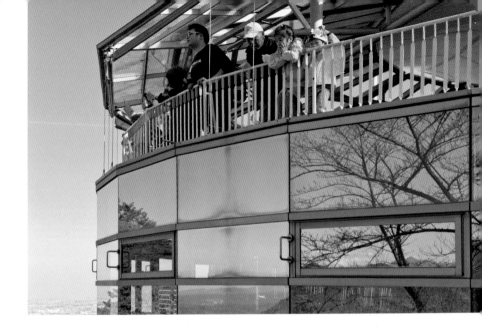

Far left A bronze Tengu awaits visitors at Yakuo-in, a mountain temple founded by Imperial decree in 744.

Center left A huge Tengu mask under the eaves of the temple's main hall at Yakuo-in.

Left Halfway up the mountain, this stylish climber is still smiling.

TOKYO TODAY

#ミテ○○ワー

Viewed from train or bus when approaching from its outskirts, Tokyo seems like a massive city assembling itself, growing taller, increasingly denser, while spreading in all directions. Flying into Haneda Airport at the edge of Tokyo Bay at night, the city's sprawling lights can completely fill the bird's-eye perspective from an airliner's cabin windows. Tokyo's vast mega city labyrinth can be a daunting prospect, but underlying the huge metropolis is a structure of town-like districts with unique characteristics, functions, and charms.

Some of Tokyo's towns originated in the city's Edo era as the shogun's base blossomed into what would become Tokyo, the Eastern Capital. Newer Tokyo towns have grown from relatively quiet train station terminals into dynamic city-like towns of eternal action and commerce. Whether marked by chic fashion, spacious parklands, or *otaku* pilgrimage sites, each Tokyo town can feel like a self-contained entity. At times, certain Tokyo towns may seem a world apart from the rest of the city.

Kids enjoy the courtyard sculpture commemorating the opening of Basuta Shinjuku, Japan's largest bus terminal.

Ueno

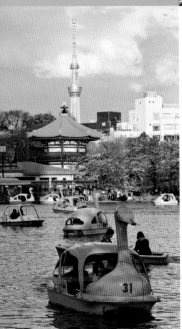

Left The bronze face of the Ueno Daibutsu, all that remains of Kanei-ji Temple's Great Buddha, the rest melted down for the war effort during World War II.

Below left Cherry blossom season at Shinobazu Pond in Ueno Onshi Park, with Bentendo Temple and Tokyo Skytree in the background.

The historic *shitamachi* town of Ueno grew in importance under the influence of the Tokugawa shogunate and was ironically the site of the Tokugawa loyalists' last stand against the restoration of Imperial rule in 1868. Ueno Park was established soon thereafter on former grounds of Kanei-ji Temple and today is Tokyo's liveliest and most popular public park. Ueno Park is home to some of Tokyo's leading museums and Japan's first and largest zoo. The spacious park also has carnival rides, fountains, promenades, the touching remains of a giant Buddha, a vermilion tunnel of Shinto *torii* gates, the natural refuge of Shinobazu Pond, and the golden Toshogu Shrine with its National Treasures. Ueno Park has a well-earned reputation for Tokyo's wildest *hanami* cherry blossom parties.

Ueno Station opened in 1883 as the gateway for the northern provinces, and the station's design remains true to its unadorned

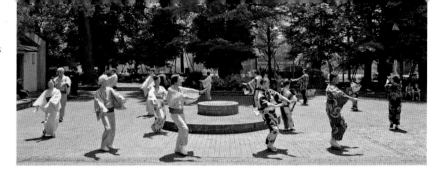

Right Neighborhood folk dancers at Ueno Park, Tokyo's liveliest and Japan's most popular park.

Above Pondering the National Museum of Western Art in Ueno Park.

Left Blossoming lotus at Shinobazu Pond in Ueno Park during a summer rainstorm.

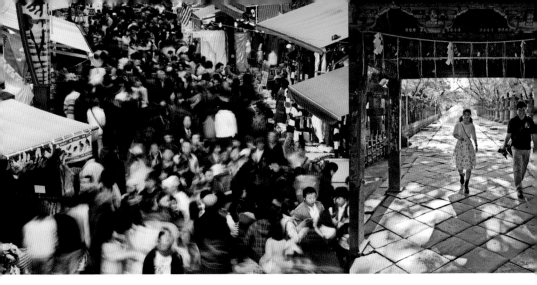

utilitarian roots. Passengers can exit directly to Ueno Park or cross over to Ameyoko, Tokyo's last surviving public market. Ueno's under the tracks alleys have the best pubs and friendliest atmosphere in the city. Pub patrons are continually rejuvenated by a surging flow of shoppers from adjacent Ameyoko, merging with others from a legion of shops and eateries that seems to stretch to infinity underneath and alongside the elevated railway.

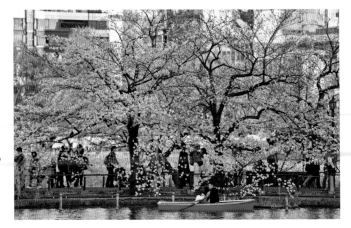

Far left Festival-like shopping on the narrow Ameyoko market street, Tokyo's last surviving public market.

Left The entrance gate at Ueno Toshogu Shrine in Ueno Park.

Right The large stone *torii* gate of Ueno Toshogu Shrine, dedicated to Tokugawa Ieyasu, the first Tokugawa shogun.

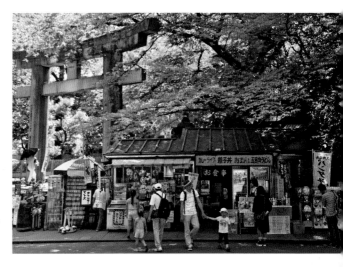

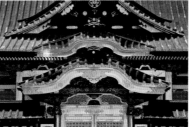

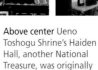

Left A rowboat and cherry blossoms at Shinobazu Pond in Ueno Onshi Park.

Above left A beautiful wooden carving of a yellow-throated bunting bird with gold foil decoration on the Sukibei Wall, a National Treasure, at Ueno Toshogu Shrine.

Above center Ueno Toshogu Shrine's Haiden Hall, another National Treasure, was originally built in 1627.

Above Very friendly pubs along the *gado-shita* "under the railway" area below the girder bridge running from Ueno Station.

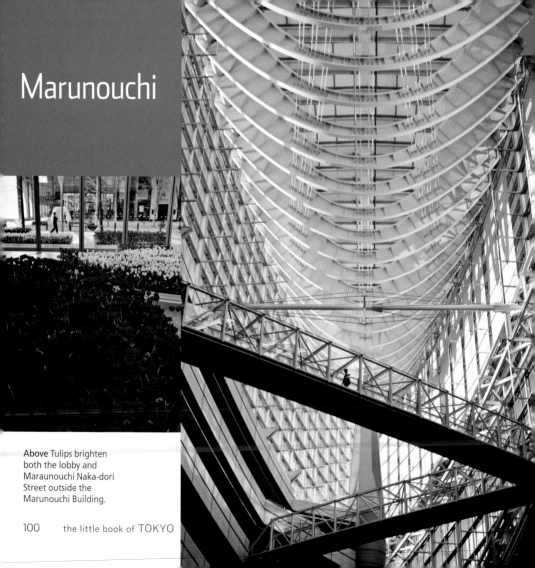

Marunouchi

Above Tulips brighten
both the lobby and
Maraunouchi Naka-dori
Street outside the
Marunouchi Building.

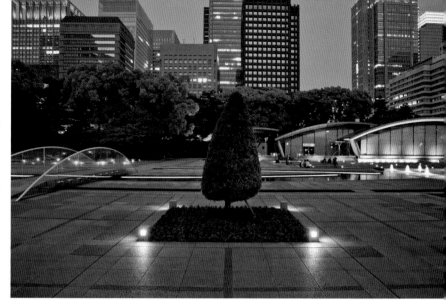

Left The International Forum's main entrance hall's 60-meter-high atrium is laminated glass and steel, with crosswalks that also provide added strength against strong winds.

Right Wadakura Fountain Park in the Imperial Palace Outer Garden.

Below The central courtyard of Tokyo International Forum is a quiet retreat at lunchtime.

Tokyo's central commercial and financial district of Marunouchi was originally an inlet of Edo Bay near Edo Castle. Supplemented with land reclaimed from the sea, the area received its name, Marunouchi, meaning "Inside the Circle," for its crucial location within the castle's outer moat. *Daimyo* estates and army barracks in Marunouchi eventually gave way to the corporate power of Mitsubishi and the dictates of city government. Now a prime location for company headquarters, Marunouchi has been invigorated with luxury boutiques and multi-function buildings offering a wide variety of dining and shopping venues.

Tokyo Station is the hub of the modern Marunouchi district and the transit center of the city and country since opening in 1914. The original Marunouchi Station Building, with distinctive red brick domes and cupolas, celebrated its 100th anniversary recently by completing

an extremely meticulous restoration that began in 1946. Tokyo Station is a rare example of preservation in a city where demolition and replacement are standard procedures. The nation's sleekest new high-speed trains, named after a romantic female poet and peregrine falcons, slide out of the historic station with exacting precision.

Above Early morning commuters at Tokyo Station, which originally opened in 1914.

Left The North Dome of the consummately restored red brick Marunouchi Station Building.

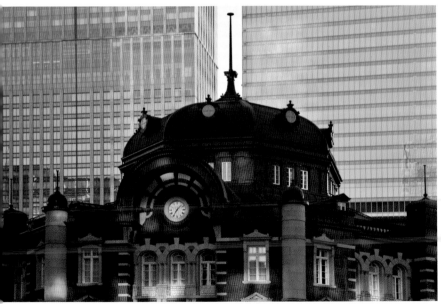

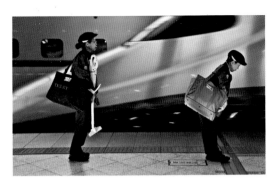

Left A dedicated cleaning crew stands fully prepared to service an arriving Shinkansen high-speed train at Tokyo Station.

Above A bronze statue of Ota Dokan (1432–1486), the samurai architect who designed and built Edo Castle, at Tokyo International Forum.

Left Sculpture that encourages interplay at Tokyo International Forum, Japan's largest conference center.

Ginza

Among the world's most luxurious shopping districts, Ginza's silvery name comes from an Edo-era mint once located there. After a devastating fire in 1872, Ginza was rebuilt in modernization efforts that embraced a Western-style street layout and more durable architectural design. The value of land in the posh Ginza

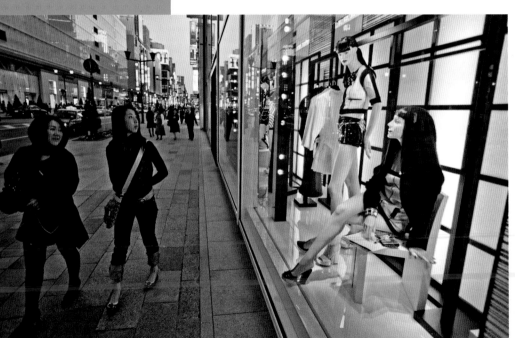

district has remained the highest in Japan for decades. A recent spike in this vaunted real estate's price is credited to heavy purchasing by Chinese tourists on "explosive" shopping sprees, dubbed *bakugai*.

Ginza's streets are lined with luxury brands and a multitude of art galleries. A walking tour of Ginza also presents an array of outstanding modern architectural designs from Japanese architects, including Ban Shigeru and Jun Aoki, and Western builders such as Renzo Piano. Like every town in Tokyo, though, change is inevitable even amidst the most glittering facades. What was a Ginza ATM corner just last month

Top left An imperturbable cat relaxes atop a street sign near Ginza Six, a new 13-story shopping mall complex.

Left Fashion inside and out on Ginza's Chuo-dori Avenue.

Above A stylish sneaker boutique at Tokyu Plaza Ginza.

Above The dynamic De Beers Ginza Building, architecture that demands attention.

Below Mikimoto Ginza 2, for the famous jewelry company, by architect Toyo Ito.

Below A Buddhist monk from sacred Mt Koya seeking alms on Central Avenue.

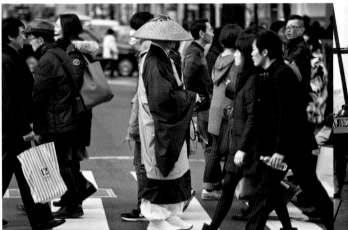

may magically reappear this week as a pocket-sized specialty boutique for Issey Miyake's Bao Bao handbags. Reassuringly, the time-honored tradition of strolling about Ginza to window shop, known as *Gin-bura*, yet endures.

Right Ginza style in retro black and white.

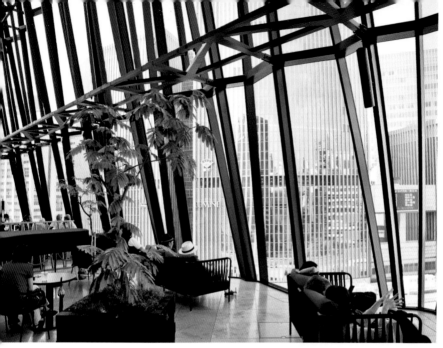

Left The Kiriko Lounge at Tokyu Plaza Ginza, located at Sukiyabashi Crossing.

Below The classic facade of a traditional sushi restaurant.

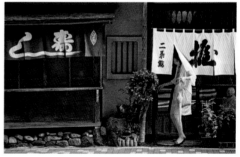

Hibiya

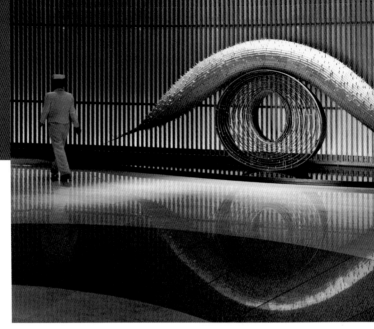

Hibiya Park is at the heart of the Hibiya district in central Tokyo. The park's land was originally reclaimed from Edo Bay in the 17th century and subsequently owned by a feudal *daimyo* provincial lord of the Tokugawa era. Later used as an army training ground, the 16 hectares was ultimately developed as Japan's first proper public park in 1903. Hibiya Park encompasses two ponds, one with a graceful bronze crane fountain and the other shaped from a portion of Edo Castle's moat and bordered by a remnant of the castle's old stone escarpment. There are scores of comfortable benches overlooking cultivated flowers, seasonal blossoms, patient gray herons, sleepy

turtles, resident cats, and darting dragonflies, with a soundtrack of splashing fountains and birdsong.

Across Hibiya-dori Street from the park is a Tokyo landmark, the Imperial Hotel, founded in 1890 at the behest of the nearby Imperial Palace, and now considered to be Japan's most famous luxury hotel. The hotel's Toko-an Teahouse offers

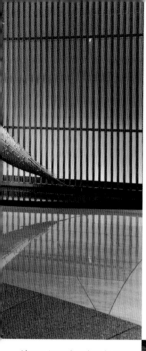

Left A bronze sculpture outside the Tokyo Takurazuka Building, home of the Takurazuka Theater's all-female musical theater troupe.

Above A vintage limousine is used for weddings and VIPs at the Peninsula Tokyo Hotel.

Above A modern bamboo sculpture inspired by traditional ikebana in the lobby of the Peninsula Tokyo Hotel.

Left Wisteria trellis and the daily news at Hibiya Park, Japan's first Western-style public park opened in 1903.

Right Japanese Pub, says the sign, one of many such establishments underneath the elevated railway tracks that run through Hibiya.

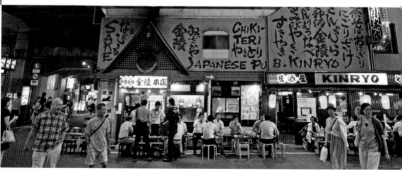

ceremonial *maccha* green tea served by tea hosts such as the charming Setsuko Tanaka, who has been preparing tea at Toko-an since 1945. From the Imperial Hotel, Hibiya merges with Yurakucho, where Japanese pubs underneath the elevated railway tracks come to life at twilight. With beer and sake flowing below, Shinkansen bullet trains slide by almost silently overhead.

Left Setsuko Tanaka has been a tea ceremony attendant at the Toko-an teahouse in the Imperial Hotel since 1945.

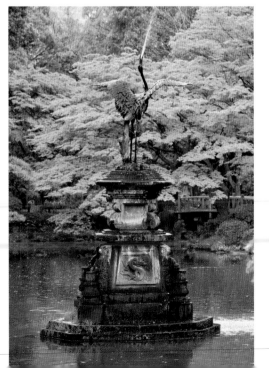

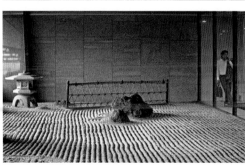

Below A courtyard sculpture at the Nissay Hibiya Building, where the Nissay Theater for the performing arts is located.

Below Felice Garden Hibiya, a German bungalow-style building dating to 1910, was the former Hibiya Park Office but now hosts weddings and the Park Archives.

Above A gracefully winding staircase and a small Zen-like rock garden inside the Peninsula Tokyo Hotel.

Far left below A *karesansui* dry landscape garden at the Imperial Hotel, Japan's first Western-style hotel, which opened in 1890.

Left The bronze crane fountain at Kumogata-ike Pond in Hibiya Park.

Right The central fountain plaza in Hibiya Park, with the Imperial Hotel in the background.

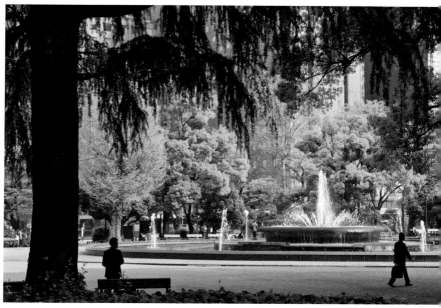

Akihabara

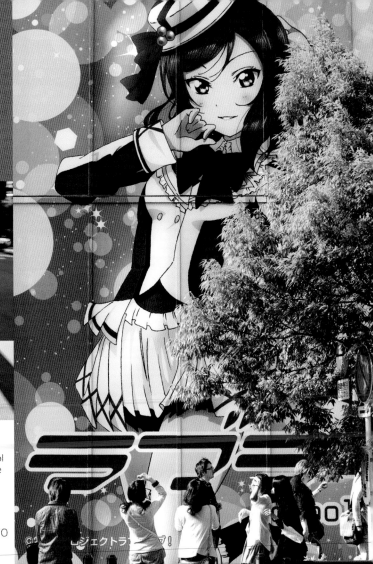

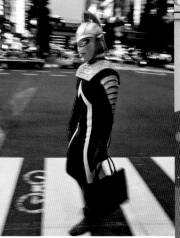

Above A young Ultraman aficionado out for a stroll along Central Avenue in an Ultra Seven full bodysuit costume.

Right A building-size mural of an anime idol on a wall of the Sofmap Main Store.

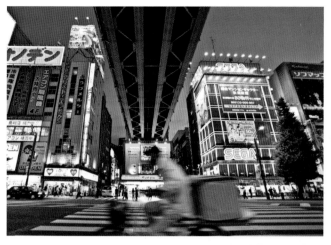

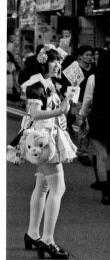

Left JR Railway tracks cross above Chuo-dori, the main avenue running through Akihabara "Electric Town."

Right A young woman in a hyper-cute costume advertising for a cosplay maid café.

Akihabara acquired its "Electric Town" nickname after the post-war surge of newly available household appliances. One can still find something as pedestrian as a washing machine in Akihabara by visiting one of the upper floors of Yodobashi Camera's "Akiba" megastore, but the Electric Town has evolved into almost sacred ground for geeky *otaku* culture. The somewhat obsessive *otaku* devotees seek gratification in Akihabara with its abundant anime shops, manga comics, video game centers, figurines, and maid cafés.

Left Life-size limited edition anime figures available, only ¥1,780,000 each.

Akihabara's many electronic shops still sell serious computer equipment and every conceivable type of gizmo and widget, but are increasingly overshadowed by massive *otaku*-oriented advertising and manga banners. Huge anime and idol posters join more traditional flashing billboards to create Akihabara's modern skyline, while cute young girls dressed as French maids and the occasional pop culture enthusiast in full Ultraman costume patrol Electric Town's streets.

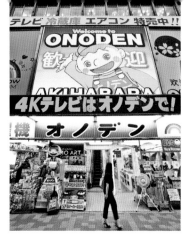

Left The main Onoden Store for electrical home appliances on Akihabara's Central Avenue.

Right Handing out fliers for a specialty maid café.

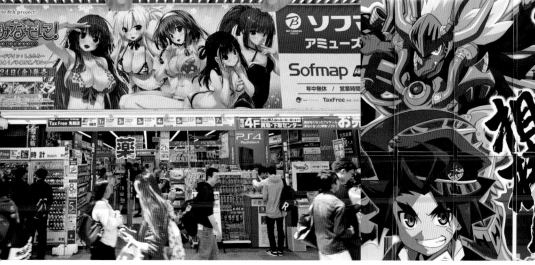

Right Cosplay maid attendants await customers at an upstairs café.

Below right The pretty girls working at Popopure Maid Café wear French maid's uniforms and welcoming smiles.

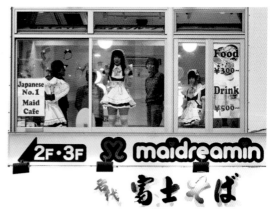

Far left Large, titillating anime advertisement at a Sofmap electronics shop on Chuo-dori Avenue.

Left A huge mural of Japanese anime characters covers a wall of the Nomura Building near Akihabara Station.

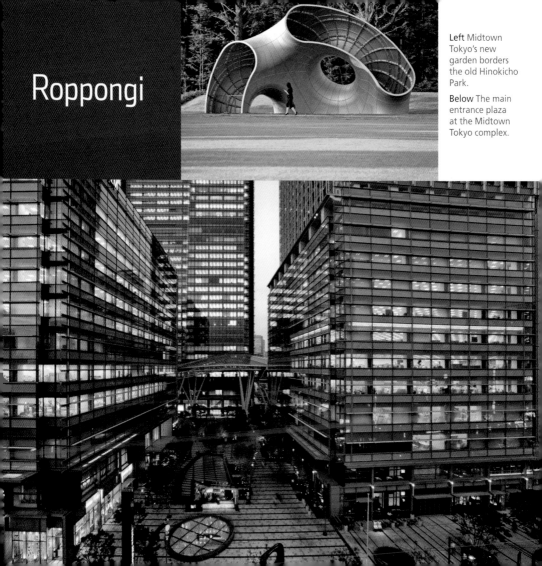

Roppongi

Left Midtown Tokyo's new garden borders the old Hinokicho Park.

Below The main entrance plaza at the Midtown Tokyo complex.

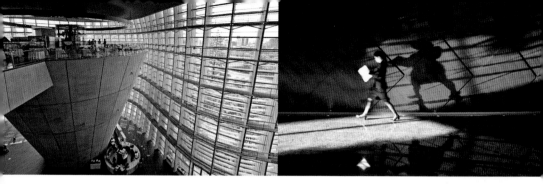

Above Tower-top cafés inside the sunny atrium of the National Art Center.

Above right Late afternoon sunlight illuminates the lobby of the Grand Hyatt Tokyo Hotel at Roppongi Hills.

With its history as a military center for both domestic and foreign forces, Roppongi became known as the most foreigner friendly nightlife district in Tokyo, with an abundant selection of bars, restaurants, and discos. A fatal accident involving a 2-ton disco chandelier that fell on top of dancers perhaps foreshadowed the end of Roppongi's disco heyday in the late 1980s. Of even greater impact, though, are several major development complexes that have recently changed Roppongi town's image and greatly broadened its daytime appeal. The Roppongi Hills mega complex is configured around the 54-story Mori Tower, a maze-like design of shops, theaters, offices, and restaurants that requires its own very complicated map. A rival complex, Tokyo Midtown, with

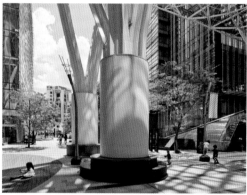

its requisite 54-story Midtown Tower, was created on the former grounds of Japan's Self-Defense Forces. The nearby National Art Center is Japan's largest art museum. Designed by architect Kisho Kurokawa, the museum's impressive lobby atrium can sometimes upstage the artwork.

Above Young visitors romp in the open plaza below Midtown Tower.

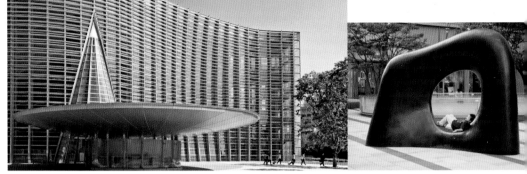

The new Roppongi complexes are most likely a glimpse of Tokyo's future, each one perhaps symbolizing some modern version of a castle town built around its monolith. Each development also displaces alley warrens, tiny gardens, old stone stairs, traditional wooden houses, hand-pump wells, and entire hillsides. Young visitors are unaware of the reconfiguration and naturally embrace the new Tokyo landscape put before them. Some things do not change, though, and the daytime lives in Roppongi town will continue to collide with the nightlife, early-bird workers encountering swaying jaywalkers or a tipsy leftover reveler missing a shoe.

Above Roppongi Crossing, a rendezvous point for revelers.

Right Beloved characters, Doraemon and his little sister Dorami, in the Metro Hat Building at Roppongi Hills.

Far left The undulating curves of the National Art Center were designed by architect Kisho Kurokawa.

Left Experiencing the plaza artwork at Tokyo Midtown.

Above right A chic boutique on Gaien Higashi Avenue.

Above far right Contemporary Zen at the Garden Terrace Atrium of Tokyo Midtown.

Right An abstract marble sculpture, circular skylight, and faux bamboo columns in an underground passage for the Roppongi Metro Station.

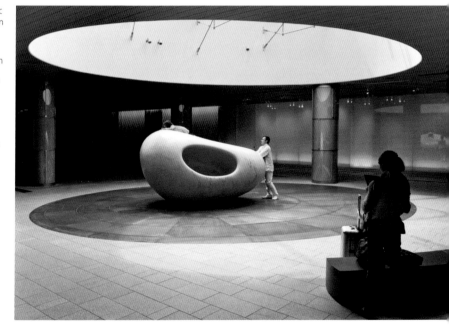

Harajuku

The European-style Harajuku Station, dating to 1924, is Tokyo's oldest surviving wooden station building but its days are numbered by "redevelopment." The station has a special rarely used platform for the Imperial Family to directly access the adjacent Meiji Shrine. Harajuku town is much more renowned for the station's opposite exit, which leads straight onto Takeshita-dori Street, a narrow lane that is the main conduit for Japan's teen culture and fashion. A river of teenagers flows down Takeshita-dori, spilling into connecting streets and alleys, always with the sweet smell of fresh crepes in the air.

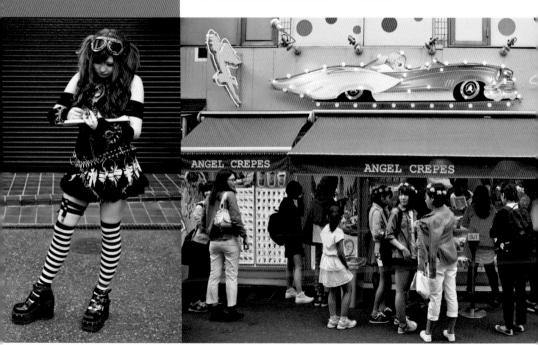

Below left This entrepreneurial designer is the perfect advertisement for her own alternative fashion boutique.

Below "Angel Crepes" is a tasty pink-hued attraction on Takeshita-dori.

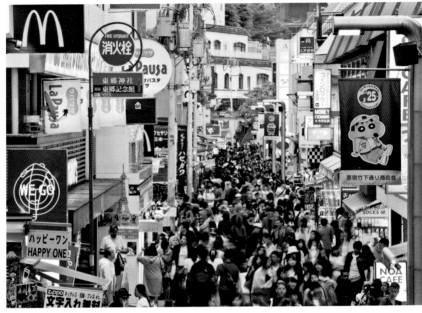

Above Raucous Takeshita-dori Street is the lifeline of youth culture in Japan.

Far left The creative commerce of style writ large on Meiji-dori Avenue.

Left Graphic graffiti meets bowler hat on a quiet lane.

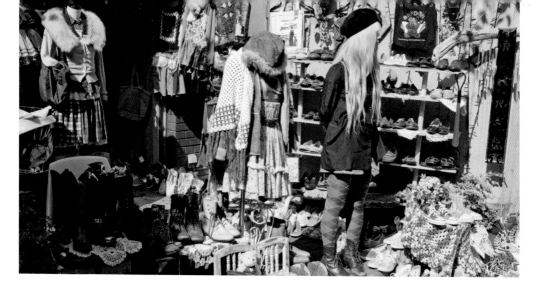

One emerges from the intricate network of trendy shops, alternative fashion boutiques with chic staff, and assorted cafés onto the broad zelkova tree-lined Omotesando Avenue, sometimes referred to as Tokyo's Champs Elysees. Here visitors will find luxury brand boutiques and more serious dining options, but also new youth-centric magnets like "Omohara," Tokyu Plaza Omotesando Harajuku, with its fascinating prism-like entrance atrium and rooftop garden patio. Omohara is easy to find across from Condomania.

Far left The job title "sales clerk" just doesn't seem to fit this striking young worker at a shop on Takeshita-dori.

Left Head to toe, cool as can be, at Laforet Harajuku.

Right Beautiful blend of personal styles outside Harajuku Station.

Left Christian Dior on Omotesando Avenue.

Right Leopard-print footwear on the corner of Meiji-dori Avenue.

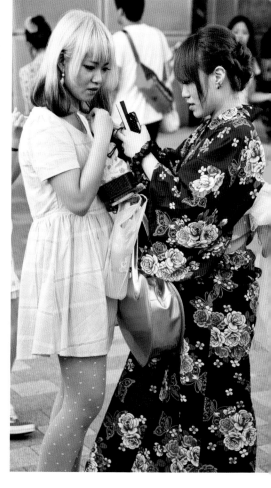

Aoyama & Omotesando

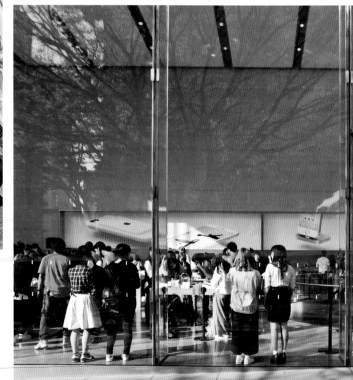

Above The transparent Prada Aoyama Epicenter on Miyuki-dori Street.

Top Finishing touches for a window display in Minami-Aoyama.

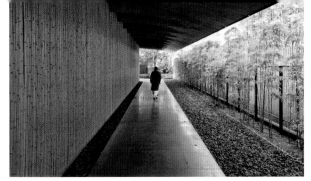

Aoyama is one of Tokyo's wealthiest neighborhoods, well known for its fashion houses of Japanese and Western designers. Once home to temples, shrines, and samurai residences during the Edo period, Aoyama acquired its name from the samurai clan mansions of Tadanari Aoyama, a magistrate for the Tokugawa shogunate. Aoyama landmarks today are the striking architectural structures situated along Miyuki-dori Street, such as the luminous Prada Building, or tucked away on side streets like Sunny Hills, a wooden basket-like creation by innovative architect Kengo Kuma.

Follow Miyuki-dori to the Nezu Museum with its surprisingly fine traditional garden, and to nearby Aoyama Reien, Japan's first public cemetery, that is isolated from main

Above left The entry garden walkway at Nezu Museum, designed by noted architect Kengo Kuma.

Left The vast glass facade of the Apple Store on Omotesando Avenue.

Above A restaurant specializing in *soba* buckwheat noodles on Aoyama-dori Avenue.

Below A debonair gentleman in a vintage convertible on Miyuki-dori Street.

streets and is replete with trees and fresh air. The compelling tomb statuary includes graves of intrepid early foreign residents and the famously loyal dog, Hachiko. Or just step onto Aoyama-dori Avenue and from a single vantage point observe tiny bars, jazz cafés, luxury boutiques of all sizes, shops reselling used luxury brands, nail salons, hair salons, chocolatiers, a Porsche showroom, Miyota Buckwheat Soba, Aoyama Kennels, Bioderma Laboratoire Dermatologique, Steiff Teddy Bears, very elegant women, and young men nattily dressed as though headed to a student council forum.

Below Niomon Gate at Zenko-ji, a Buddhist temple founded in 1601, located just off Aoyama-dori.

Right A small flower shop on a back street in Minami-Aoyama.

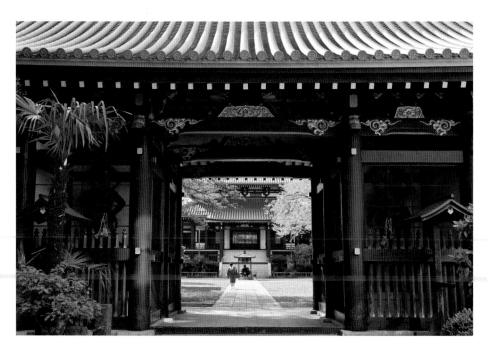

Right A graceful stone Buddha with a moss-covered headdress in the garden at Nezu Museum.

Below right The natural wood facade of Sunny Hills, yet another inventive design by architect Kengo Kuma, symbolizes a woven bamboo basket.

Below left The soothing interior of *hinoki* cypress wood lattice, *washi* paper, and simple plywood wall panels at Sunny Hills, a tasty Taiwanese pineapple cake shop in Minami-Aoyama.

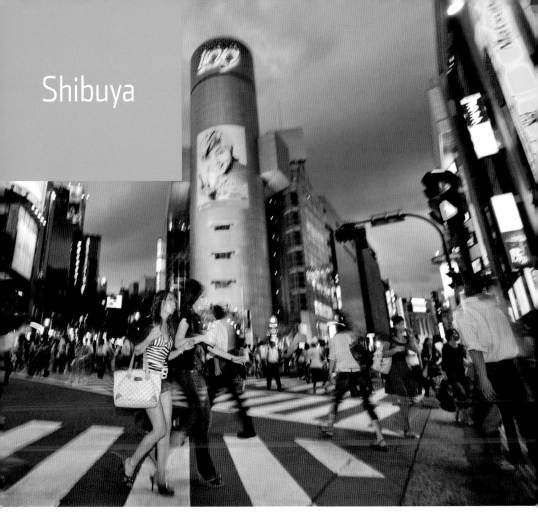

Shibuya

Left Dogenzaka Crossing at twilight.

Right A blend of fashion and architecture on Inokashira-dori Street.

Far right A stylish young woman and an elegant Buddhist monk at Shibuya Station.

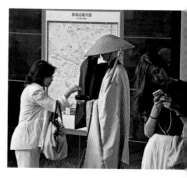

Right The elevated track of the Yamanote Line passes over the busy pedestrian "scramble crossing" at Shibuya Station.

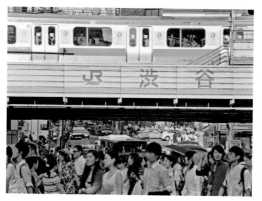

Thought to originally be the site of the Shibuya clan's castle in the Edo period, Shibuya grew as a railway terminal town after the Yamanote Line trains started running in 1885. Shibuya Station now opens onto the famous scramble crossing where pedestrians from all directions meet and somehow manage to merge effortlessly at the center of the broad intersection. Shibuya is undeniably a "Young Town," a center for youth fashion and culture, where a dozen major department stores compete with innumerable small boutiques for the essential shopper. Shibuya's streets are an ongoing fashion show of styles that are impeccably casual, against a pop architecture backdrop of odd lanes, such as the narrow Spain-zaka slope of tiny shops.

Shibuya is experiencing an ongoing makeover with major redevelopment of the station and its surroundings. Below the surface, an already completed expansion by architect Tadao Ando, the master of minimalist concrete, created a *chichusen* "underground spaceship" to accommodate a new subway line. Whatever the latest changes, surely the station's most famous symbol, a statue of the loyal Akita dog, Hachiko, will be incorporated. The beloved Hachiko always waited quietly outside the old Shibuya Station for his master to return from work at Tokyo University, and continued to do so devotedly for years even after the professor died in 1925.

Above A pastel stream of pedestrians tinted with neon.

Above right Shibuya chic, graffiti, and Tokugawa Ieyasu in Drunkard's Alley by Shibuya Station.

Right A stationary taxi surrounded by a swarm of people and cars on Koen-dori Avenue.

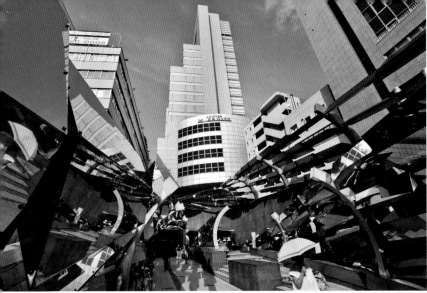

Left The Dogenzaka entrance of the Shibuya Mark City complex.

Below left An elaborate system of escalators moves passengers inside the new metro subway station designed by respected architect Tadao Ando.

Below Architect Ando's *chichusen* "Underground Spaceship" subway station uses the airflow of moving trains to save electricity and reduce carbon dioxide emissions.

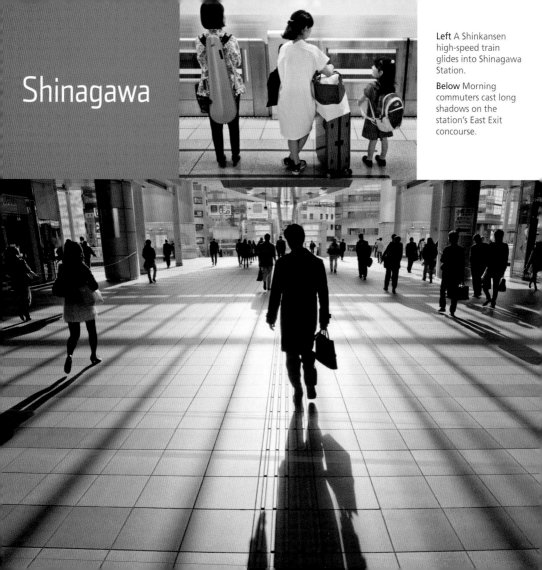

Shinagawa

Left A Shinkansen high-speed train glides into Shinagawa Station.

Below Morning commuters cast long shadows on the station's East Exit concourse.

Shinagawa dates to the 8th century but was especially known as the first post town on the Edo-period Tokaido road connecting Edo to the Imperial capital of Kyoto. Shinagawa was Edo's main lodging town and a rowdy mercantile hub as well, reflected in its name, which means "River of Goods." When the new Emperor Meiji first visited the city he had rechristened Tokyo, the Eastern Capital, he rested overnight in Shinagawa. A British Legation member witnessed the Emperor's arrival: "The Mikado's black-lacquered palanquin was to us a curious novelty. As it passed along the silence which fell upon the crowd was striking." The teenage Emperor riding inside was to see the city and Japan grow into the modern age.

Shinagawa Station, one of Japan's oldest rail stations, remains an important transit point from its location along the southern rim of the circular Yamanote

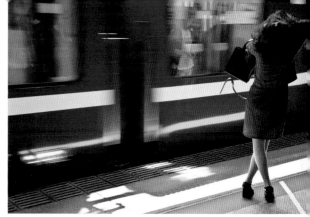

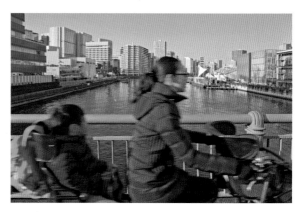

Top left Rooftop billboards promote perpetual beauty in the south side Konan district.

Top A composition in red frames poise and motion on the Keikyu Line train platform at Shina-gawa Station.

Above A *mama-chari* "mom's bike" crosses a canal at Tennozu Isle.

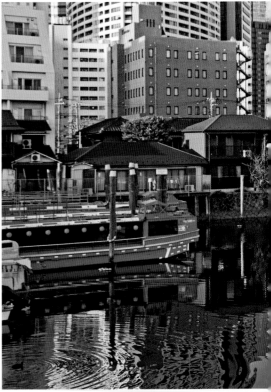

Line and is fittingly now the first station on the Tokaido Shinkansen Line headed towards Kyoto from Tokyo. Shinagawa is still Tokyo's main lodging town as well, with the largest concentration of hotels in the city. A major network of office skyscrapers, Shinagawa Grand Commons and Shinagawa Intercity, extends from the Konan side of Shinagawa Station, accessed along an elevated walkway that surrounds and crosses over a large central courtyard garden. Further afield, in the midst of corporate headquarters, one can find canals and houseboat docks that retain a faint trace of Shinagawa's Edo days at the edge of the bay.

Above A quiet moment of solitude in Shinagawa Central Garden.

Right The Kita-Shinagawa canal harbor for *yakatabune* excursion boats.

Top right Local residents worshipping at the hilltop Shinagawa Jinja, a Shinto shrine dating to the early 12th century.

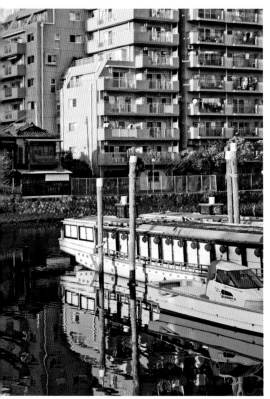

Center right A Parking Enforcement Officer writing a ticket on Tennozu Isle. Their pesky determination and emerald uniforms have earned such officials the unflattering nickname "Green Bugs."

Right Green space at Shinagawa Central Garden, enclosed by the corporate space of Shinagawa's Grand Commons and Intercity complexes.

Shinjuku

Above Staff stand by to assist a handicapped passenger arriving at Track 1 inside Shinjuku Station.

Right Snow-capped Mt Fuji rises dramatically behind the Shinjuku skyline.

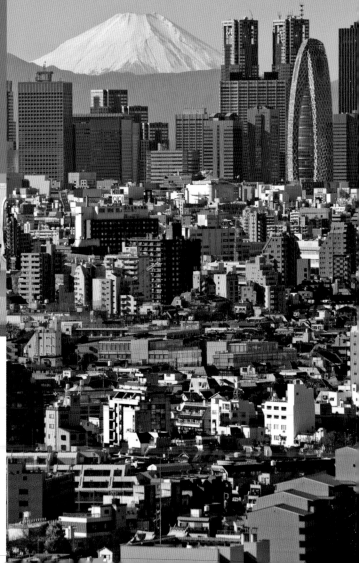

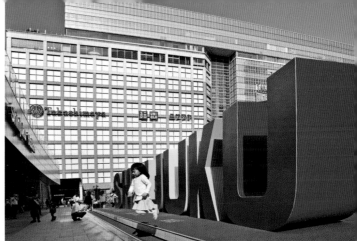

Shinjuku is split into east and west by Shinjuku Station. The post town that sprang up around an Edo-era roadway in the 17th century is now home to the busiest railway station in the world. The Shinjuku Station area is a major economic dynamo for Tokyo, with its many corporate headquarters and major retail stores spreading out from the station hub. To the south is the massive Taka-shimaya Times Square department store and shops, all connected by walkways to the station, and the newest addition, the Shinjuku Expressway Bus Terminal. Named "Basuta" by popular vote, the terminal has a rooftop vegetable garden with rental plots, modern bus gates, and a sleek office tower attached.

Above left Building-size anime posters and elevated railway tracks near Shinjuku Station.

Above A colorful sculpture to celebrate the opening of Basuta bus terminal leads to Takashimaya Times Square department store at the New South Exit of Shinjuku Station.

Center left A skywalk connects Takashimaya Times Square and Kinokuniya Bookstore.

Left A towering karaoke pub on Yasukuni Avenue.

West Shinjuku has Japan's largest concentration of skyscrapers, including the Tokyo Metropolitan Government Center designed by renowned architect Kenzo Tange. East Shinjuku is less staid. Its infamous Kabukicho is Tokyo's largest red-light district and also boasts Tokyo's latest icon—a "life-size" Godzilla head peering menacingly from the roof of the new Toho Cinemas Building. Further east is one of the most sedate spots in Tokyo, the Shinjuku Gyoen National Gardens, a former Edo *daimyo*'s estate and Imperial Garden. Shinjuku Gyoen is beautifully landscaped with a variety of gardens and is spacious enough to almost get lost in.

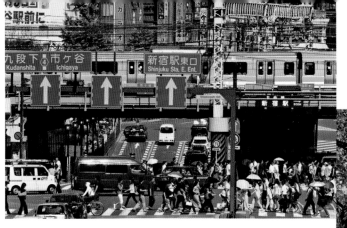

Above An orderly procession of pedestrians, vehicles, and trains at Yasukuni-dori Avenue.

Below left A collage of signs at the edge of the Kabukicho entertainment district.

Below Smokers are not welcome inside Shinjuku Station, the world's busiest railway hub.

Below Spring is in the air at Shinjuku Gyoen National Gardens.

Right A gigantic Godzilla lurks atop the Shinjuku Toho Building.

Below Shinjuku Southern Terrace across from the South Entrance of Shinjuku Station.

Ikebukuro

PACHINKO

When one tires of bumping into tourists in Tokyo that too closely resemble relatives back home, it's time to head for Ikebukuro. Located at the northern apex of Tokyo's Yamanote Line circuit, Ikebukuro nurtured dreams of becoming a super town of skyscrapers when Sunshine 60 was completed in 1978. The boom never followed, though, and the 60-story building stands virtually alone. With Ikebukuro's growing reputation as an alternative oasis for *otaku* culture, the sentinel skyscraper has recently renovated and rebranded its former observation floor as Sky Circus Sunshine 60 Observatory, promoting more than just a view-only experience to attract fresh visitors. There are still sweeping panoramas of the city, but Sky Circus also features interactive virtual reality rides using virtual reality goggles, optical illusions, kaleidoscopic effects, special lighting, and even some retro fun house mirrors.

Right Bronze gymnasts outside the main east entrance of Ikebukuro Station.

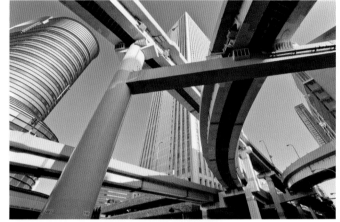

Above The Shuto Expressway maze and the Sunshine 60 Building.

Left A stack of excellent pubs by the west exit of Ikebukuro Station.

Top left The entrance to Pokemon Center Mega Tokyo at the Sunshine City complex.

Left A pachinko parlor with anime posters out front.

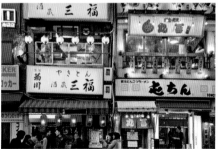

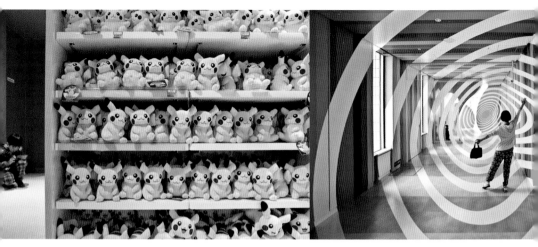

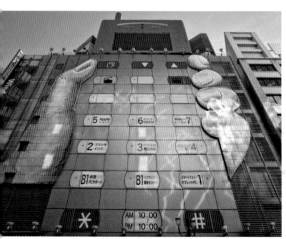

Left A monumental cellphone at Bic Camera's multi-story main computer store on Meiji-dori Street.

Right The aesthetic lobby of the Concert Hall and Symphony Space at the Tokyo Metropolitan Theater.

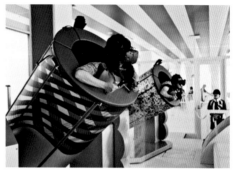

Far left Pikachu dolls fully stocked at the Pokemon Center Mega Tokyo, the largest Pokemon anime goods outlet in Japan.

Left The Spiral Shot hallway for upside-down optical snap-shots at the "Sky Circus" Sunshine 60 Observatory.

Above left The Swing Coaster offers visitors a virtual cruise above Ikebukuro using virtual reality goggles at "Sky Circus" atop the Sunshine 60 Building.

Above right Human cannonballs? No, it's the Tokyo Bullet Flight, to experience a virtual reality journey over futuristic Tokyo at "Sky Circus."

Left Looking out from the "Sky Circus" Sunshine 60 Observatory, with the city at their feet.

The adjacent Sunshine City also boosted Ikebukuro's *otaku* status with the newly opened Pokemon Center Mega Tokyo, where thousands of yellow Pikachu dolls are available for both kids and older anime fans with shopping baskets in hand. Even Tokyo Governor Yuriko Koike recently pitched in to promote her former Ikebukuro legislative district, appearing at the Ikebukuro Halloween Cosplay Fes. The always stylish governor was dressed as Princess Sapphire, a character created by the prolific "father of manga," Osamu Tezuka.

TOKYO
SIGHTS

It's difficult to comprehend the sheer size of Tokyo, so huge that it requires a governor, not a mayor. No individual could ever know the entire city. Not even a Google Maps Camera Car can penetrate Tokyo's interior arteries. The daunting scale of such a mega city makes finding an insightful perspective a special challenge. British journalist Peter Popham wrote: "Every modern city is a machine, but Tokyo is more perfectly so, more elaborately so." As the world's largest city, Tokyo is a *massive* machine that can be confusing even on the best days. Tokyo's maze of millions condensed into a city structure with no set grid and often confounding layout calls for approach strategies to help make sense of the place.

Tokyo has many excellent observatories, each with a unique atmosphere, which can provide overviews of the city's vastness and help to reveal some of the surrounding pieces in the Tokyo puzzle. A long circuit around the vital core of Tokyo on a bush warbler green train of the Yamanote Line loop railway can provide helpful insights into town-like districts, and even reveal underlying topographic elements of the city. More intimate regions can be accessed at a slower pace aboard one of Tokyo's last surviving streetcars or by exploring city waterways on a water bus or riverside path. Sometimes, just a simple walk between train stations can uncover hidden attractions in Tokyo's epoch-thick layers.

See-through architecture at Odaiba.

Meiji Shrine

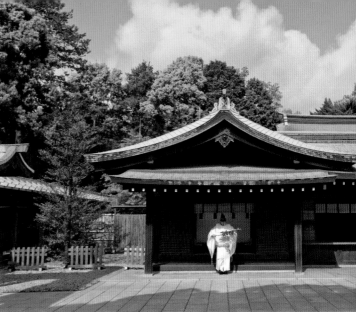

Below A mother and daughter attend the Shichi-Go-San ceremony for children aged 7, 5, and 3.

Right A young *kannushi* priest with a sacred *sakaki* branch used as a purifying wand at the Shukeisha Hall.

Meiji Jingu Shrine is a calm sanctuary at the heart of Tokyo, built in 1920 to honor the souls of revered Emperor Meiji and Empress Shoken. The shrine's Yoyogi Forest is a 70,000-hectare woodland that includes zelkova, cherry, camphor, and oak trees, and encompasses the original iris garden designed by the Emperor for his consort. The solemn forest, now nearly 100 years old, was created with 100,000 trees donated from all across the country, each planted by hand with the help of a vast legion of young volunteers. Meiji Jingu's recently opened Forest Terrace café and its furniture were crafted using wood from fallen trees in the shrine's forest. The Emperor's iris garden still flourishes, tenderly cultivated by a team of dedicated gardeners, and is especially beautiful during the misty drizzle of the rainy season.

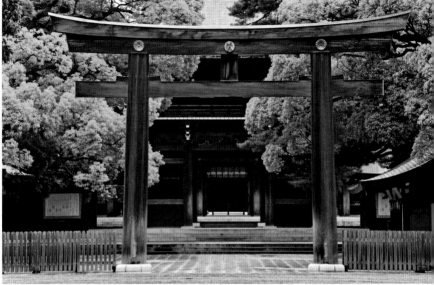

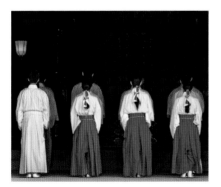

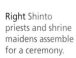

Right Shinto priests and shrine maidens assemble for a ceremony.

Above A cypress *torii* gate with Imperial Chrysanthemum Crests marks the entrance to the central sanctuary.

Right Finely crafted wooden doors are pitted with indentations from coins tossed by enthusiastic worshippers at New Year.

Meiji Jingu's impressive *torii* gates with their Imperial Chrysanthemum Crests, and the shrine's traditional Shinto halls are constructed of fragrant *hinoki* cypress wood. A sacred pair of large camphor trees joined together by a *shimenawa* rice straw rope stand inside the spacious courtyard before the Honden main hall, the "wedded" trees romantic symbols of harmonious union and familial fortune. The Honden's large wooden doors allow a glimpse

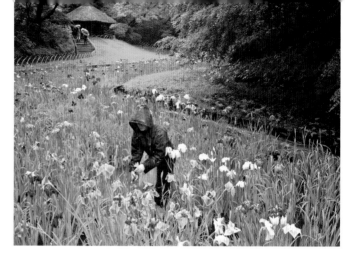

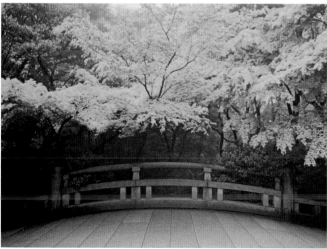

Left A stone bridge arches underneath Japanese maple trees glistening with rainy season mist in the shrine's Inner Garden.

Above An elite female gardener tends to the carefully cultivated Iris Garden.

into Meiji Jingu's holy Naien inner precinct reserved for ritual ceremonies. A closer look at these richly grained doors reveals a pattern of rough crescent-shaped indentations, the result of a flurry of *sansen*, the coins tossed as offerings by the massive throngs of dedicated worshipers that make their way to Meiji Shrine at Japanese New Year.

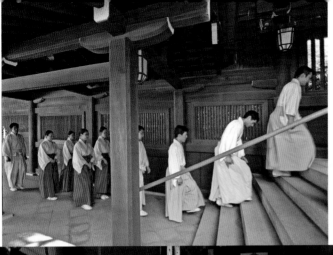

Left Priests and shrine maidens proceed through an alcove to the Honden main hall.

Below A *miko* attendant is dwarfed by the Honden's voluminous portico.

Above A wooden *ema* votive tablet for prayers and wishes that reads "To Meiji Emperor, I want to become the C.E.O.!!"

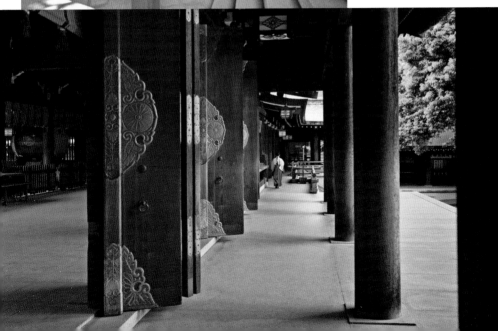

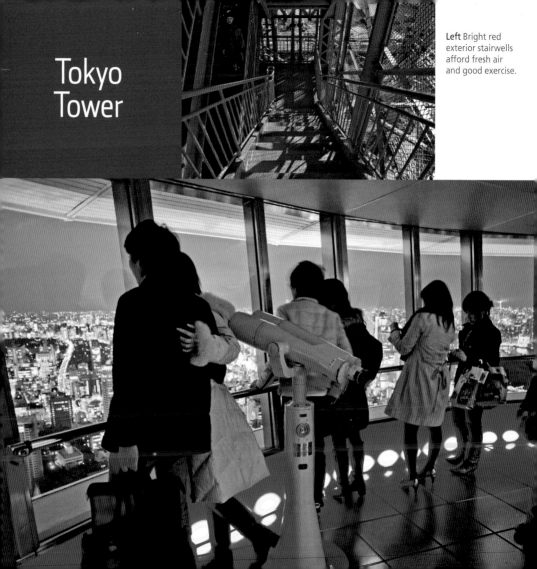

Tokyo Tower

Left Bright red exterior stairwells afford fresh air and good exercise.

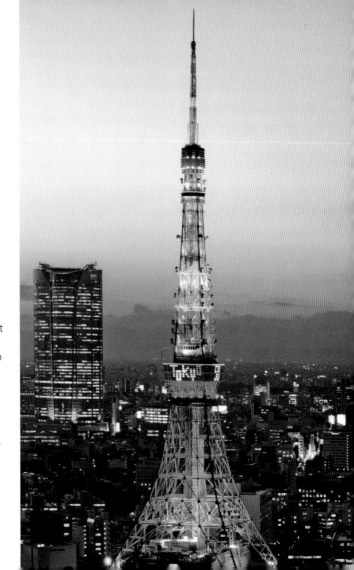

Below left Couples, in particular, favor panoramic evening views from the upper observatory.

Right The graceful steel girder lattice design was inspired by Paris's Eiffel Tower.

A symbol of recovery and optimism after the Pacific War's devastation, Tokyo Tower opened to great fanfare in 1958. Modeled after the Eiffel Tower in Paris, architect Tachu Naito designed Tokyo's tower to be just a bit taller, proudly creating the world's highest free-standing tower at the time. Tokyo Tower's 333-meter height was initially vital for communications, but the current requirements of digital terrestrial television are better served by Tokyo Skytree, which is nearly twice as tall. The romantic appeal of Tokyo Tower keeps growing stronger, though. The local government has even taken the extraordinary step of zoning regulations to protect unencumbered views of the esteemed tower from excessive high-rise development.

Painted white and international orange to fulfill aviation regulations, the curves and colors of the prefabricated steel girder latticework tower now seem gracefully delicate, with perhaps a hint of kitsch. Inside, kitsch is not a question, it's game on. Tokyo Tower houses a wax museum, a hologram gallery, an aquarium, the Guinness World Records Museum, the Club 333 performance stage, a Shinto shrine, numerous souvenir shops and cafés, and a food court. Above all, the city views from Tokyo Tower's two observatory levels are striking, day or night. One can see people standing on top of Mori Tower over in Roppongi, but couples especially prefer Tokyo Tower's more romantic twilight cityscapes.

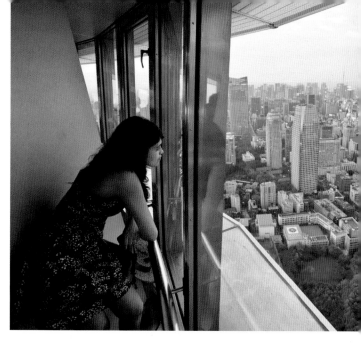

Above A comfortable twilight view of Tokyo's vastness from the Special Observatory.

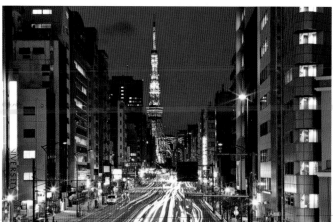

Right Tokyo Tower highlights the cityscape at Sakurada-dori Street.

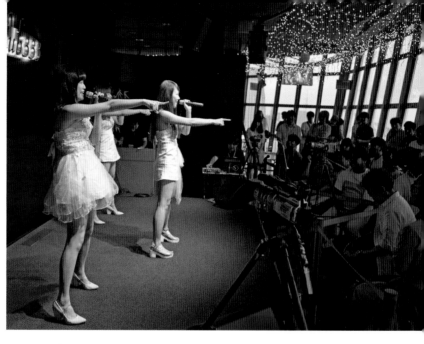

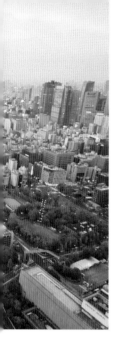

Above The Club 333 Stage at the Main Observatory takes its name from Tokyo Tower's height of 333 meters.

Right A stylish attendant stands ready to greet visitors ascending by elevator.

Right A gleaming indicator panel for the essential elevators.

Circling Tokyo by Train

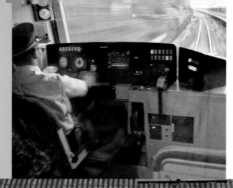

Left Yamanote trains, one running clockwise, the other counter-clockwise, circle the railway's double-track loop around the city.

Right Osaki Station, where all Yamanote Line trains are put into and taken out of service.

Below The train platform at Shin-Okubo Station stretches above Okubo-dori Street.

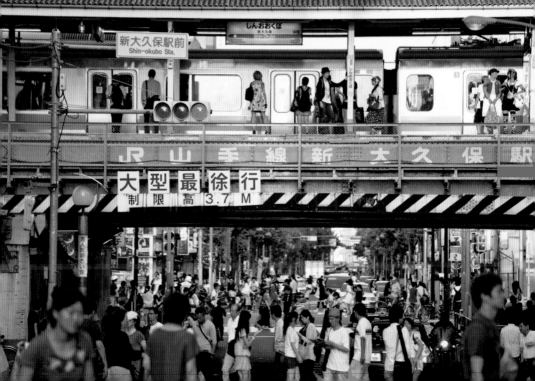

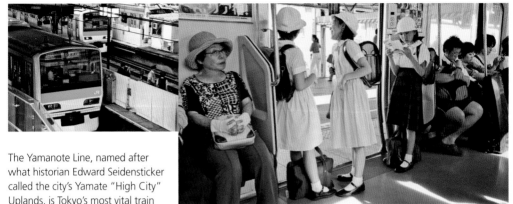

The Yamanote Line, named after what historian Edward Seidensticker called the city's Yamate "High City" Uplands, is Tokyo's most vital train line, connecting many of its major stations and urban centers. The Yamanote Line is a loop railway, running from before dawn until after midnight. Its trains, each 200 meters long, flow in and out of the line's 29 stations for a complete circuit, which takes about an hour. Riding one of the color-coded trains (officially Japanese Bush Warbler Green) provides a glimpse of Tokyo's incredible transport infrastructure that operates with to-the-minute efficiency approaching perfection. A full circuit also affords views of the Musashino Plateau, river valleys, and the alluvial plain lowlands that define the city's underlying form. A 30th Yamanote station will soon

Above Schoolgirls in uniform with leather *randoseru* backpacks ride the Yamanote Line.

Left An array of ticket vending machines and city train maps at Otsuka Station.

fill the only available gap between stations.

Circle the city on the Yamanote Line, eyes on the cinematic landscape outside or the handsome humanity inside with, generally speaking, nobody busy picking any pockets. When something interest-ing is spotted from a window, alight at any station with no fear of stumbling into a dangerous neighborhood. The only worry might be finding your way back or to the next station. Then again, there's no better or friendlier metropolis to get a bit lost in than Tokyo.

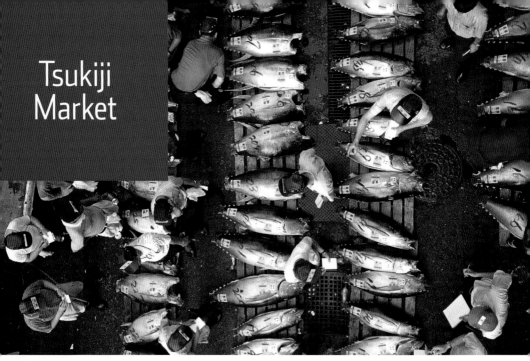

Tsukiji
Market

After a devastating fire in 1657, the Edo shogunate initiated a land reclamation project using earth from extensive moat and canal building projects. The newly constructed land created on lowland marshes at the edge of Edo Bay was named Tsukiji, literally "built land." Originally a quiet district of samurai and *daimyo* residences, Tsukiji expanded as an early approved residential area for foreigners, with an added focus on healthcare and education when St. Luke's International Hospital mission was founded there in 1902. The relocation of Tokyo's main fish market to Tsukiji after the Great Kanto Earthquake transformed the district into a vibrant thriving mercantile center.

Left A veteran worker with a sword-like knife prepares frozen tuna for auction at Tsukiji Market, the biggest wholesale fish and seafood market in the world.

Left A tiny café for early morning clientele on a narrow lane at Tsukiji Market.

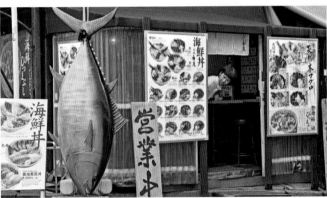

Tsukiji Market is Japan's great Food Town, a diverse mix of wholesale and retail shops and restaurants stretching along the north bank of the Sumida River at Kachidoki Bridge. The inner restricted precinct, known officially as the Tokyo Central Wholesale Market (tentatively scheduled for relocation to other reclaimed land further out in Tokyo Bay), contains the world's largest fish market, renowned for its pre-dawn tuna auctions, where a single *very* choice bluefin tuna famously sold for $1.8 million. Tsukiji's Outer Market mixes wholesale and retail, with a warren of shops offering Japanese kitchenware and restaurant supplies amidst tempting grilled crab legs, iced oysters, skewered octopus, and live prawns so fresh they occasionally jump right out of their tanks into the alleyway.

Above left Fresh tuna being auctioned at the inner Tokyo Metropolitan Central Wholesale Market.

Far left A traditional wooden sign with a carved *fugu* pufferish at a seafood restaurant in Tsukiji's outer market area.

Above An unpretentious Tsukiji seafood restaurant specializing in tuna.

Right A regular customer outfitted with classic woven "Tsukiji baskets" and standard rubber boots in the outer market area.

Tokyo's Last Streetcar

Like the Yamanote Line, the Toden Arakawa streetcar line also has 29 stations but there the similarity ends. Dating to 1913, the Toden Arakawa Line is the last survivor of Tokyo's once extensive Toden streetcar system. Its single-carriage trams traverse a humble 12-kilometer arc across the city's northern districts from Minowabashi in northeast *shitamachi* to Waseda by the Kanda River in the northwest. These last Toden streetcars travel through virtually uncharted territory, running right off the top of many Tokyo maps.

Trams are known as *chin chin densha* for their distinctive bells, but a Toden Arakawa streetcar bell

Above Roses line the tram tracks at Minowabashi Station, the eastern terminus of the Toden Arakawa Line.

Right No-frills Gakushuin-shita Station on the long slope leading down to the Kanda River in Toshima Ward.

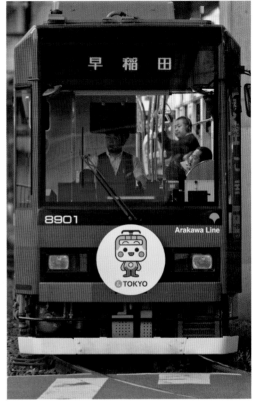

sounds more like "burring burring" as it goes clickety-clack down the narrow tracks. The tram line passes through a labyrinth of back streets and crossroads, often bordered by the fragrant rose bushes the Toden Arakawa is known for, roses with such flowery names as "Simply Heaven," "Blue River," and "Frankly Scarlet." The Toden Arakawa Line stations are simple platforms with no gates or ticket machines, and when one of the little trams occasionally trundles past a major city rail station the contrast is poignant. This venerable Tokyo streetcar is as unassuming as the northern neighborhoods it connects.

Top left A Toden streetcar mural near Minowabashi Station where the electric tram line begins its 12-kilometer arc to the northwest.

Above An electric tram waits to merge with street traffic at Ojiekimae Station. The Arakawa Line is the last survivor of Tokyo's once extensive Toden streetcar system.

Tokyo Skytree

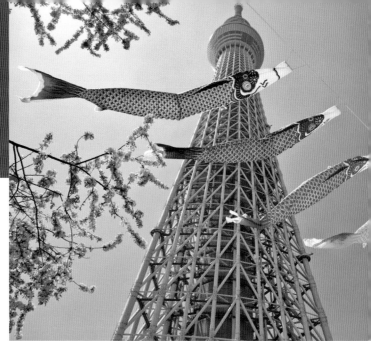

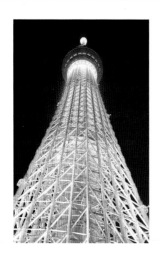

Above The 634-meter Skytree is visually transformed by evening illumination.

Above A "family" of *koinobori* carp streamers heralds Children's Day at the Sky Arena Plaza.

Left The uppermost Tembo Galleria Observation Deck encircling the world's tallest free-standing broadcast tower.

Tokyo Skytree has single-handedly redrawn the map of Tokyo—most Tokyo maps anyway, as pre-Skytree tourist maps of the city seldom offered any detail beyond Asakusa, with anything east across the Sumida River rendered like New Jersey on a New York City map. All new Tokyo maps simply must include the new landmark and its surroundings in the once remote *Shitamachi* "Low City" of Sumida Ward. Tokyo Skytree is the result of a brilliant plan by Tobu Railways with Japanese broadcasters: build the world's tallest observatory and communications tower on spare land from a Tobu Railway freight depot! More than 1.6 million visitors were whisked to the top during Tokyo Skytree's first week alone.

From all the shutters clicking around the huge tower's base and up on both observatory levels, one could make the case for Tokyo Skytree being the planet's busiest photo spot. The Skytree's pinnacle offers the ultimate pilot's-eye view, like being in a soaring plane, overlooking the entire Kanto region. It's up on the tower's Tembo Deck that the automated Multi-Camera Control System of 12 digital cameras

Right Senso-ji Temple's Pagoda and Tokyo Skytree. The tower's engineers incorporated the extraordinarily resilient strength of traditional pagoda design in the internal structure of Skytree.

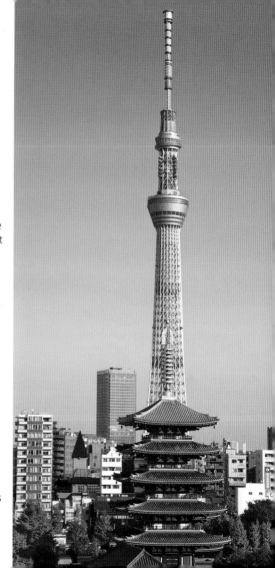

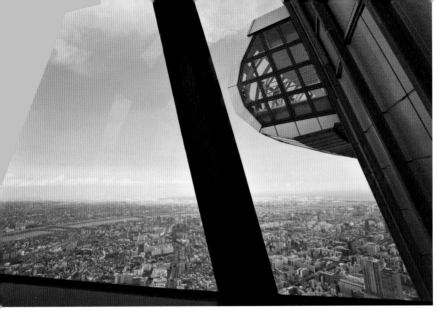

Right A sweeping view, and nice shadow, on the Tembo Observation Deck.

is installed, continuously photographing the 360-degree view 24 hours a day to record the changing city vistas of seasonal elements and luminance for posterity.

Above A glimpse of the wraparound walkway in Skytree's upper precinct.

Right Skytree staff respectfully greet early morning visitors in the main entrance lobby.

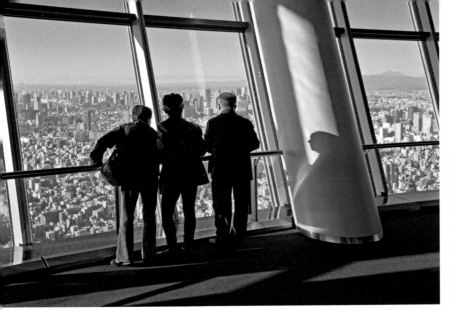

Below left An attendant in a Skytree motif uniform by the elevator for the yet higher observatory level.

Below Exuberant visitors take in views of the surrounding city and document the experience.

Kiyosumi Garden

Thought to originally be part of an Edo business magnate's residence, Kiyosumi Garden near the Sumida River in Fukagawa was later the Edo residence of a feudal *daimyo* lord. The garden was rebuilt during the Meiji period by three generations of the Iwasaki family, founders of Mitsubishi. Fine stones carefully

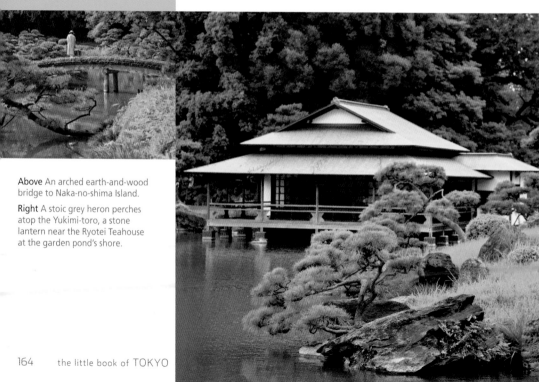

Above An arched earth-and-wood bridge to Naka-no-shima Island.

Right A stoic grey heron perches atop the Yukimi-toro, a stone lantern near the Ryotei Teahouse at the garden pond's shore.

selected from all over Japan were transported up the Sumida by the company's steamships, and the river's waters were also used to greatly expand the Kiyosumi garden pond.

The Ryotei Teahouse is built at the pond's shore, extending gracefully out over the water. Kiyosumi Garden is especially known for its *iso-watari*, a path of stepping stones through shallow water, which affords close-up encounters with carp, turtles, and waterfowl along the edge of the large pond. Kiyosumi Garden is bordered with 4,000 trees, making it a fine spot for bird watching year round. Recently, the Kiyosumi

Opposite top A path of stones along the shore of Dai-Sensui Pond encourages leisurely contemplation, step by step.

Below Students with umbrellas add color to the snowy garden.

Bottom An unusually tall *tsukubai* stone water basin near the garden's entrance.

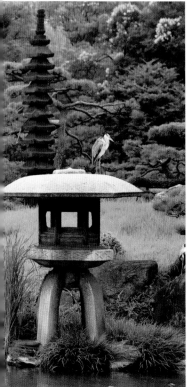

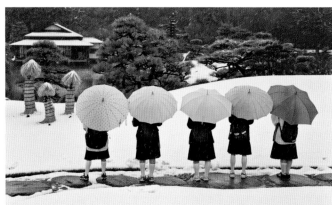

gardeners hosted a group of French staff members from Versailles, allowing their foreign counterparts an intimate perspective on the techniques of traditional Japanese garden design and maintenance, and perhaps sharing a few trade secrets.

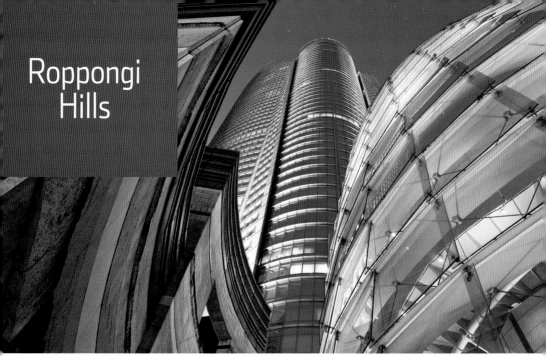

Roppongi Hills

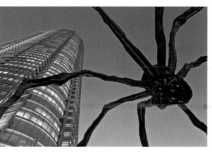

Far left A summit-like sunset atop the open-air observatory Sky Deck.

Left The giant spider "Maman" is a bronze, stainless steel, and marble sculpture in Roku Roku Plaza beneath Mori Tower.

Mori Tower is a legacy of Taikichiro Mori, a building tycoon who was the world's richest man at his peak. Some consider Mori to be the individual who most greatly changed the face of Tokyo with his company's modern office buildings, in such profusion that he opted to number them in lieu of names. The 54-story Mori Tower is the centerpiece of the Roppongi Hills complex completed in 2003 by Mori's son, Minoru. The monolith shoots straight up from the spacious Roku Roku Plaza, making the courtyard's giant "Maman" sculpture of a bronze, stainless steel, and marble spider seem tiny in comparison.

The Sky Galleries of the City View observation deck are located on the 52nd floor, high above the corporate offices of Google and Goldman

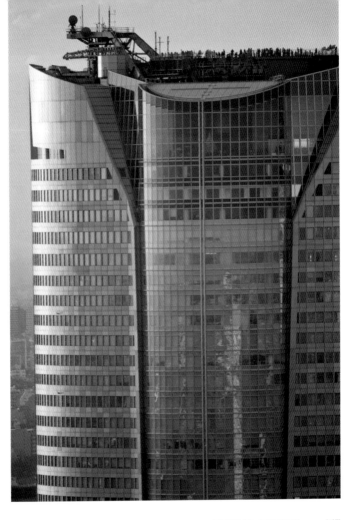

Above left
Architectural angles collide at the Museum Cone entrance to the Mori Art Museum and 54-story Mori Tower.

Right A close look reveals visitors crowding the rooftop observatory of Mori Tower.

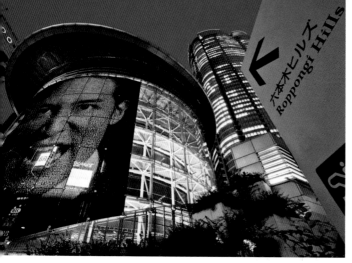

Sachs. The Mori Arts Center Gallery and the Mori Art Museum, which exhibit contemporary Japanese, Asian, and Western art, share the City View's sweeping panoramic angles of Tokyo. Weather permitting, the tower's pièce de résistance is the rooftop Sky Deck. The highest outdoor observation deck in Tokyo, it can feel almost like being on top of a mountain in the middle of the city, especially at sunset. Fellow "climbers" gather at the rooftop's western rim to watch the sun slowly sink behind real mountains in the distance while illuminating the vast cityscape in between.

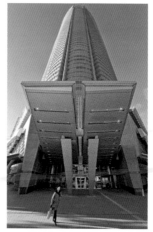

Top The Metro Hat pavilion, often swathed in huge advertisements, is the main entrance to Roppongi Hills.

Above A gallery interior at the high-altitude Mori Art Museum.

Left A dramatic entrance to Mori Tower from Roku-Roku Plaza.

Opposite above left A twilight tableau with bare trees and vivid winter sky.

Opposite above right Observatory visitors linger at sunset.

Right An overview from the large windows of the Tokyo City View observatory includes the orange-colored Tokyo Tower in the distance.

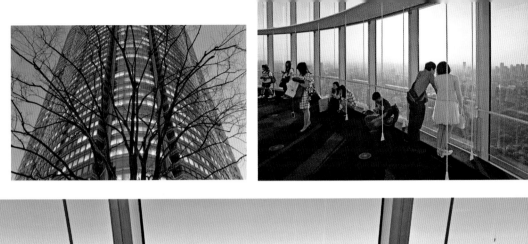
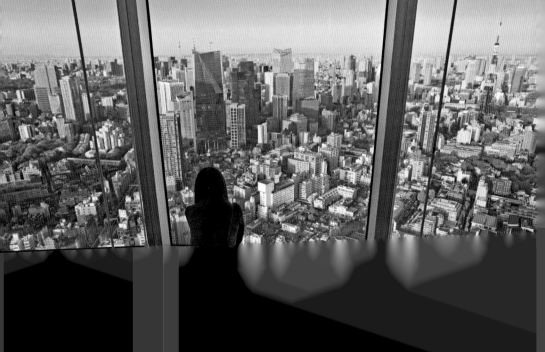

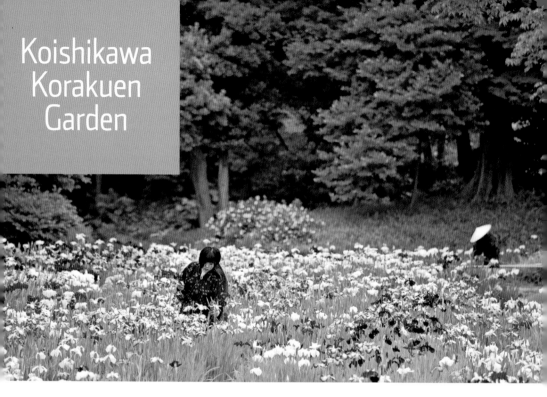

Koishikawa Korakuen Garden

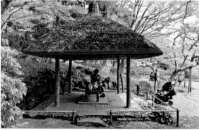

Far left Scarecrows protect drying rice that was harvested from the garden paddies.

Left A woman with two small children relaxes at a thatched roof garden pavilion.

Left Gardeners carefully tend the *shobu* iris paddies at Koishikawa Korakuen.

Right Cherry blossoms frame two young women in silk kimono on the bridge at Dai-Sensui Pond.

Below right Vermilion-hued Tsutenkyo Bridge arches gracefully over a hillside stream.

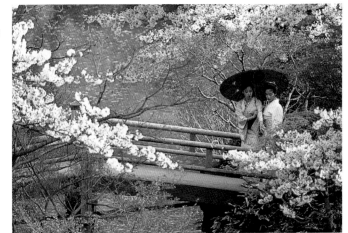

Koishikawa Korakuen is an outstanding Edo-period *daimyo* garden, originally built in 1629 as the Edo estate of the Mito clan. The estate was strategically located so as to guard the approach to Edo Castle from the north, as well as to protect the city's vital Kandagawa Josui water supply canal network. The garden paths of the spacious *kaiyu* circuit-style Koishikawa Korakuen encompass an amazing variety of scenery and nature, highlighting the genius of Japanese garden design. The garden is designated a special place of scenic beauty as well as a special historic site, a rare double award by the Japanese cultural properties protection law. The outer garden wall of large fitted stones with distinctive quarry imprints alerts the observant visitor to the Zen-like treasures within.

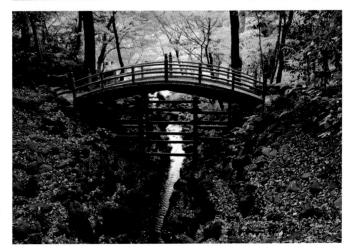

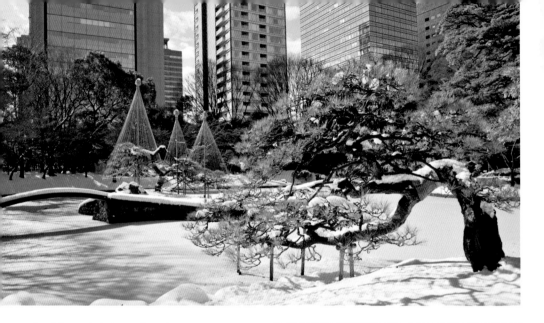

Carefully tended pine and maple trees create backdrops for a variety of garden bridges inside Koishika-wa Korakuen. A gracefully arched vermilion-hued wooden bridge connects hills at the garden's highest point, and the stone arch of the Engetsu-kyo Bridge completes a full moon with its reflection. A simple bridge of stepping stones languorously curves its way across a shallow pond, while the equally minimalist Yatsuhashi Bridge of

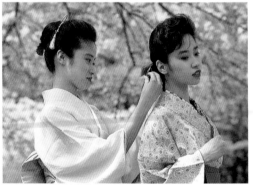

Above Protective snow ropes shield pine trees by the partially frozen Naitei Pond of the Naitei Inner Garden.

Right Traditionally attired sisters collaborate under a canopy of cherry blossoms.

Left The stepping stones of the Sawa-watari marsh crossing require careful negotiation.

Below Yatsubashi is a bridge of eight wooden planks laid across a paddy used for iris or rice, depending on the season.

eight wooden planks spans a flowerbed of iris. Dedicated amateur bird photographers with long telephoto lenses are attracted to the shore of Koishikawa Korakuen's central pond, where they wait patiently for a *kawasemi*, hoping to capture the flashing split-second dive of the kingfisher.

Rainbow Bridge

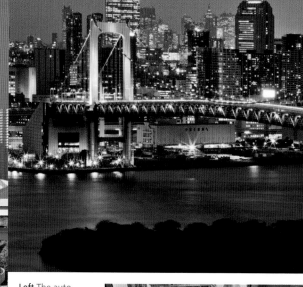

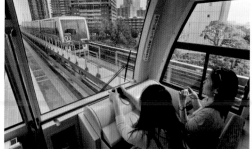

Left The automated New Transit Yurikamome Line curves past Ariake Sports Center after crossing Rainbow Bridge.

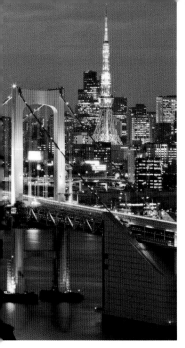

Tokyo is technically a port city, but unchecked commercial development largely obliterated public access to the water's edge with an unending stretch of commercial piers, warehouses, and restricted wharfs. It was nearly impossible to reach the bay until the construction of Rainbow Bridge in 1993 and the Yurikamome Line in 1995, with both providing easy approaches to the Tokyo Bay Waterfront on Odaiba Island.

Rainbow Bridge, crossing northern Tokyo Bay from Shibaura Pier, is illuminated with multicolored hues in the evening by solar lamps charged during the day. The suspension bridge has promenade walkways for an invigorating hike across, with dramatic views of Tokyo's skyline, ship's passing directly underneath, and traditional *yakatabune* houseboats gathering in Odaiba's harbor. The driverless New Transit Yurikamome, an automated guideway system train named for the bay's common black-headed seagull, makes a sweeping curve up and over the sea on Rainbow Bridge's lower deck. The elevated Yurikamome's route around the island is an inexpensive outing unto itself, but many tempting Odaiba sights warrant getting off for a closer look.

Left Sitting up front on the driverless Yurikamome elevated train.

Above Rainbow Bridge, with its namesake arch of colors, and Tokyo Tower at twilight.

Top right A replica of the French Statue of Liberty and the real Rainbow Bridge are both illuminated in the evening.

Right An art college student working on a watercolor painting of the popular Rainbow Bridge stretching across the bay.

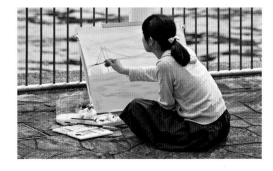

Odaiba New City

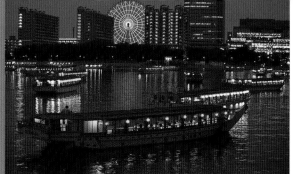

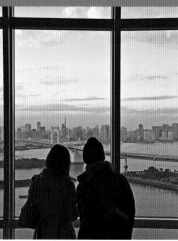

Above A young couple looks out on Tokyo Bay and Rainbow Bridge from the observatory atop Fuji TV Headquarters.

Top *Yakatabune* excursion boats and the island's ferris wheel color the evening bay at Odaiba.

The man-made island of Odaiba was created in Tokyo Bay using landfill to join together some of the small fort islands built by the Tokugawa shogunate in the late Edo period to protect the city from the threatening gunboat diplomacy of Commodore Perry's Black Ships. The much-enlarged Odaiba was the result of a huge development project by the Tokyo Metropolitan Government during the "bubble economy" boom of the 1980s, with futuristic visions that ran out of money and steam when the economy tanked.

The Odaiba project was revived by the completion of Rainbow Bridge and the Yurikamome Line, both providing easy access, and by the government's rezoning the island to permit entertainment venues. Odaiba's DiverCity Tokyo Plaza is quite entertaining, starting with a first impression of the looming "life-size" Gundam figure standing guard outside. As part of what will hopefully become a ritual changing of the iconic guardian giants, the former 18-meter-tall *mecha* was recently dismantled and replaced by an even more gargantuan Unicorn Gundam. Inside, the mall has tax-free shopping, an impressive food court, and free Wi-Fi. The island's Tokyo Big Sight, Japan's largest convention and exhibition center, also makes a strong impact with its geometric glass-and-titanium Conference Tower, while the Maritime Museum clearly defines itself with a ship-shaped design, including a fine crow's nest observatory on top.

Left The seven-story glass tube escalator at the Fuji TV Head-quarters.

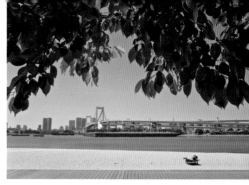

Above The wide sandy beach at Kaihin-koen Marine Park on Odaiba, a large artificial island originally built for defensive purposes in the 1850s.

Left The monumental architectural scale and distinctive spherical observation platform of the Fuji TV Head-quarters Building are signatures of architect Kenzo Tange.

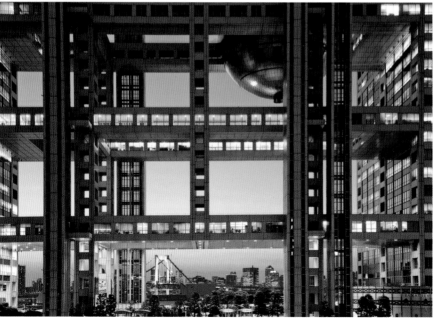

Shinjuku's City Hall

Left The Assembly Hall observatory offers a dramatic view of the twin steeples of the Tokyo Metropolitan Government Center.

Below Citizens' Plaza and the Tokyo Metropolitan Government No. 1 Building, designed by acclaimed 20th-century architect Kenzo Tange.

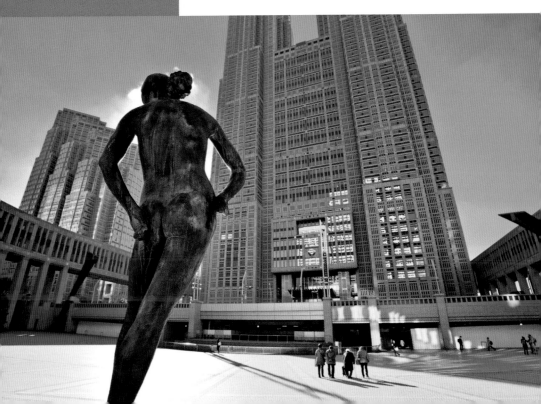

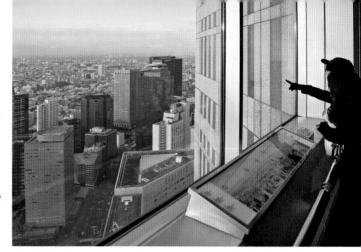

After much bureaucratic discussion, Tokyo's city bosses decided to relocate their headquarters from Marunouchi to Shinjuku in 1991, and enlisted one of the world's outstanding architects, Kenzo Tange, to create their new home. The government's Tokyo Metropolitan Main Building No. 1 is a 48-story tower designed in Tange's signature "Japanese Monumental" style, situated on city property just beyond the pod of skyscrapers west of Shinjuku Station. The tower splits, somewhat Gothic-like, into two pinnacles with panoramic observatories at the top of each. In a surprising gesture of service to all, whether tax-paying citizen or not, admission is free.

The observatories atop city hall offer unimpeded perspectives in all directions, including close-up angles on the other nearby Shinjuku skyscrapers. Distant views are limited only by atmospheric conditions. Visitors can linger, have a coffee, maybe try the adjacent turret's lookout, and consider any interesting target areas below to explore. The North Observatory stays open later into the evening for savoring that beautiful interlude when the city's lights begin to flicker on amid the glowing twilight.

Above The City Hall observatories are a free, visitor-friendly destination high above the city.

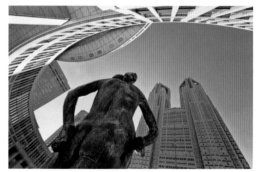

Top The North Observation Deck, one of two atop Tokyo Metropolitan Government No. 1 Building.

Above Citizens' Plaza is a spacious public square beneath the twin towers of the Tokyo Metropolitan Government Building.

Olympic Tokyo

Left Olympic judo is commemorated on the bridge at Yoyogi National Stadium, the 2020 venue for Olympic handball and Paralympic badminton and wheelchair rugby.

Modern Tokyo, with its impressively efficient infrastructure and mass transit systems, also has Olympic know-how and hands-on experience from the 1964 Games held in the capital, the first Olympic games ever held in Asia. The 2020 Tokyo Olympics and Paralympics offered the city, now the largest ever to host the Summer Olympics, a chance to dust off and refurbish some of the still serviceable 1964 Olympic facilities, such as Yoyogi National Stadium and Tokyo Metropolitan Gymnasium. The 1964 National Stadium, however, has given way to a new Olympic Stadium, and the creation by innovative Japanese architect Kengo Kuma is the 2020 Games' centerpiece.

Kuma envisioned an Olympic Park area with a new National Stadium built on a human scale intended to blend into the surrounding cityscape rather than stand out like a monument. Located within a stone's throw of Shinjuku Gyoen Park's vast green veld and adjacent to Tokyo Metropolitan Gymnasium, as well as the nearby green

Above The central courtyard of the Tokyo International Forum, which is the 2020 venue for Olympic weightlifting and Paralympic powerlifting.

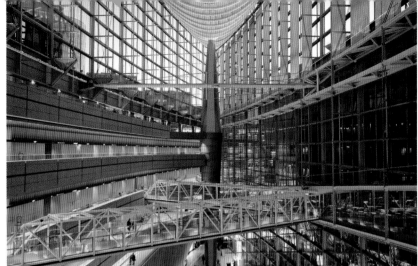

Below The Main Arena of the Tokyo Metropolitan Gymnasium, designed by architect Fumihiko Maki.

outer gardens of Meiji Jingu just to the east, the new stadium site budgeted 66,000 trees in accordance with the architect's plan for a "stadium in the forest." Olympic Tokyo incorporates two main operational districts: the Heritage Zone with its Olympic Park and the Tokyo Bay Zone featuring futuristic urban venues. The Olympic Village, located between the zones and constructed from scratch, was conceived as an eco-town powered by non-polluting hydrogen that will provide thousands of public housing units after the games.

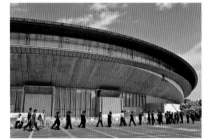

Top The 60-meter atrium at Tokyo International Forum, a part of the 2020 Olympiad's Heritage Zone.

Above Tokyo Metropolitan Gymnasium is the 2020 venue for Olympic and Paralympic table tennis.

Above right An official souvenir towel with the logo for the Tokyo 2020 Summer Olympics.

Shinjuku Gyoen Park

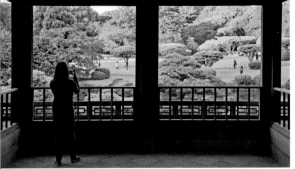

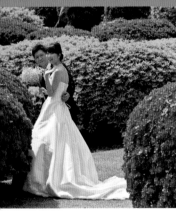

Above Young newlyweds pose amidst floral beauty on the park's Azalea Hill.

Top The Chinese-style Kyu-Goryo-Tei Taiwan Pavilion.

Shinjuku Gyoen is one of Tokyo's most beautiful Edo-era legacies, a sprawling and spacious park of gardens that forms a verdant oasis, its inviting green space just a short walk from the world's busiest railway station in Shinjuku. The park has evolved through many manifestations. Originally an Edo *daimyo*'s estate turned experimental agriculture center, it then became a botanical garden with horticultural greenhouses until becoming an Imperial Garden eventually shared with the public and now administered by the Ministry of Environment with the official name of Shinjuku Gyoen National Garden.

The striking floral beauty of Shinjuku Gyoen Park reflects its rich botanical history. The park's meadows and woodlands of 20,000 trees include apricot, magnolia, sycamore, ginkgo, maple, plane, cypress, chestnut, and zelkova, graced with 1,500 of the most impressive cherry trees to be found anywhere. Azalea hillsides brushed by palettes of red and scarlet tint the garden ponds with painterly reflections. The huge cherry trees at full blossom create thick snowstorm-like swirls of delicate pink petals when spring winds blow. Shinjuku Gyoen's nearly 61 hectares offer enough room to wander or catch a nap.

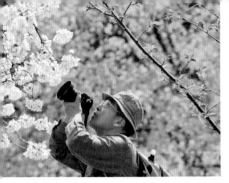

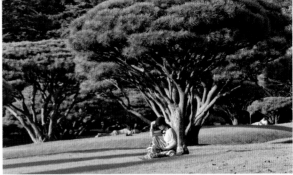

Above center
The sheer volume and variety of cherry blossoms make focusing a delightful challenge.

Above A gentle grassed slope with *akamatsu* red pines can soothe the soul.

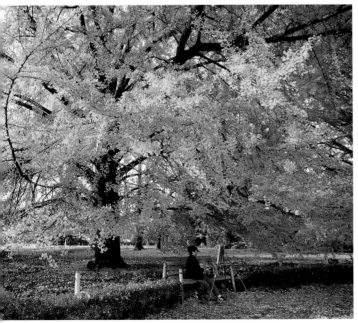

Left and above A painter seeks inspiration amidst arboreal beauty.

World Trade Center

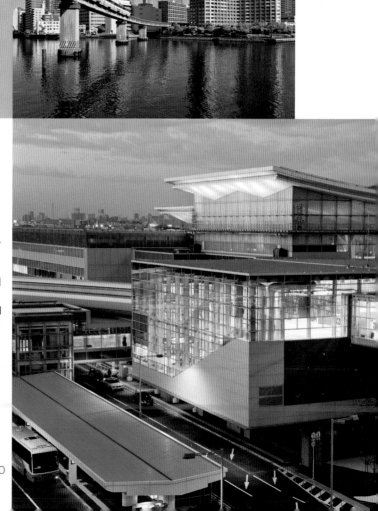

Tokyo's World Trade Center Observatory and Tokyo Monorail offer relatively vintage perspectives on the city. The World Trade Center, a 40-story commercial building completed in 1970, is one of Japan's earliest skyscrapers. The Tokyo Monorail predates it, running since the 1964 Summer Olympics. The friendly and relaxed observatory at the World Trade Center was recently renovated and rebranded as Seaside Top and, laid back as ever, still offers the city's best view of Tokyo Tower as well as fine perspectives on Tokyo Bay and the former Imperial garden, Kyu Shiba Rikyu, right below it.

From the center's lower levels, it's easy to board the Tokyo Monorail that connects the

Left The Tokyo Monorail, officially the Tokyo Monorail Haneda Airport Line, glides above the bay water's at Shibaura Island.

Below The monorail runs right through Haneda Airport's new International Terminal Building.

Right Businessmen and travelers aboard the elevated monorail.

Far right The "Seaside Top" observatory on the 40th floor of Tokyo's World Trade Center.

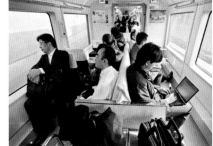

surrounding Hamamatsucho area with the Haneda Airport terminals on Tokyo Bay. The elevated six-car monorail trains traverse eleven stations, gliding along the bay's shoreline of wharfs and canals, passing over the horse stables at Oi Racecourse, and actually running right through the Haneda Airport International Terminal. Officially renamed Tokyo International Airport, the new terminal has an "Edo Koji" shopping level that strives to reflect the ambiance of the old city, including a half-scale reconstruction of historic Nihonbashi Bridge made of Japanese cypress. The airport terminal, with an architectural design inspired by cirrus clouds that fills it with natural light, is an interesting monorail destination even without intending to board a plane.

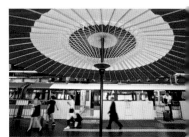

Above A vivid *bangasa* paper umbrella on the train platform at Monorail Hamamatsucho Station inside the WTC.

Below A charming receptionist greets visitors at the express elevator for the "Seaside Top" observatory.

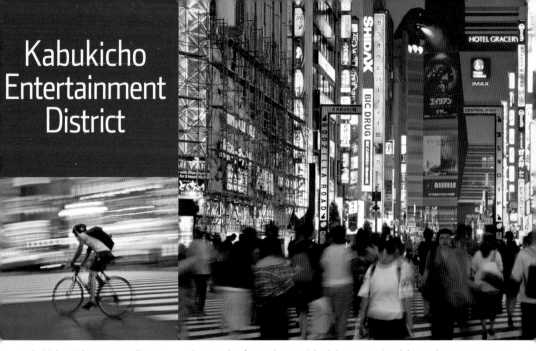

Kabukicho Entertainment District

Kabukicho, Tokyo's most vibrant and somewhat naughty nightlife district, was once a swamp and duck sanctuary, which after World War II was slated to host a kabuki theater that never materialized due to finances. The name stuck, and the district was ultimately transformed from a residential neighborhood into an infamous red-light venue now boasting thousands of grogshops, nightclubs of the hostess and host persuasion, multi-themed love hotels, theaters, a Robot Restaurant, manga cafés, and questionable massage parlors. The J Pop and Rock music blasted from the exterior speakers of numerous pachinko establishments, mixed with public address announcements warning unwary punters and pedestrians of tricky upstairs clubs or close encounters with moving vehicles, create Kabukicho's clamorous soundtrack.

Oddly enough, the giant Godzilla staring menacingly from a rooftop terrace overlooking Kabukicho's Central Road is a new symbol of the district's healthier daytime attractions for consumer shopping, cinematic, and culinary appetites. Kabukicho's Godzilla, which roars

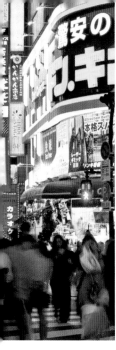

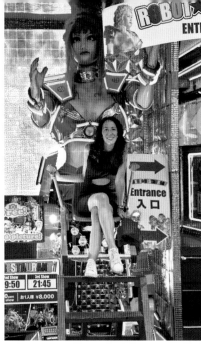

Center left Kabukicho's Central Road leads to Japanese film giant Toho's latest cinema complex and hotel, with Godzilla on top.

Left A robot model attraction at the entrance to the Robot Restaurant, an alternative dinner theater mixing historical drama and futuristic fantasy.

Below A small back alley bar in Shinjuku's Kabukicho entertainment district, open all night.

Bottom Godzilla keeps a close watch over the heart of Kabukicho.

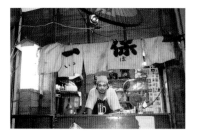

Above far left A bike courier streaks past a whirling wall of Kabukicho neon on Yasukuni-dori Street.

and belches steaming mist on the hour, gained added nostalgic value with the recent passing of Haruo Nakajima, the Japanese actor who brought the original monster movie Godzilla to life in 1954, stomping miniature Tokyo film sets in a 90-kilogram rubber suit while striving to project the pathos of the misunderstood irradiated creature in the process.

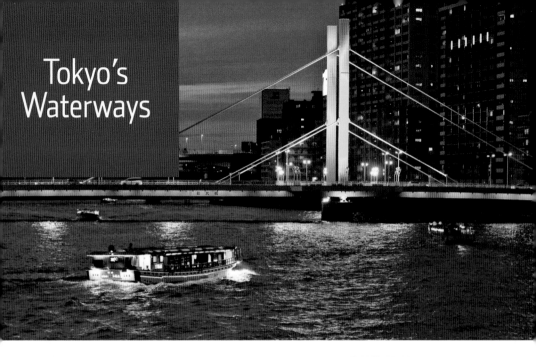

Tokyo's Waterways

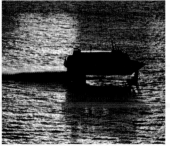

Far left A brightly colored Gozabune cruise ship that features onboard entertainment and dinner during its Tokyo Bay voyages.

Left A high-speed hydrofoil ferry cuts through skyscraper shadows in Tokyo Bay.

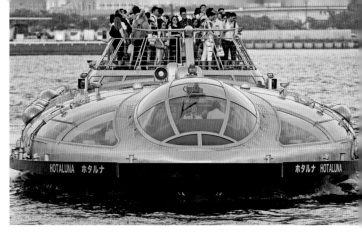

Tokyo's streets and expressways are perpetually filled with far too many vehicles, but the city's waterways are amazingly free of boat traffic, to the point where one might wish for more. Recent expansions in Tokyo's water bus network are encouraging, inspiring hope for alternate city transport, but new ferries such as the one from Haneda Airport are still special attractions, not regular transportation. Water buses do operate in Tokyo Bay, offering especially

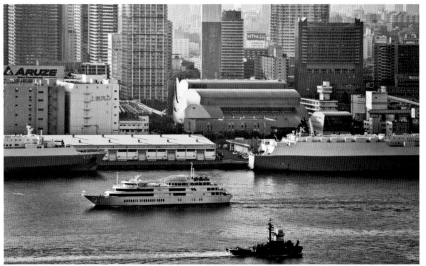

Opposite above *Yakatabune* cruising houseboats and Shin-Ohashi Bridge, built across the Sumida River in 1976.

Above A futuristic Hotaluna water bus, designed by anime artist Leiji Matsumoto.

Left A large cruise ship and a work-horse tugboat passing Shibaura Pier.

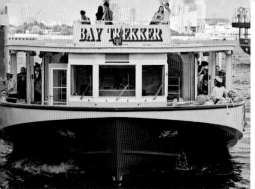

Above A Bay Trekker water bus at Hinode Sanbashi Pier on the edge of Tokyo Bay.

Above center The decorative iron railing of the Sumida River's Kuramaebashi Bridge depicts a sumo wrestler in honor of the nearby Kokugikan sumo arena.

Right A jet ski speeds under Sakurabashi Bridge, the first pedestrian bridge over the Sumida River, with Tokyo Skytree beyond.

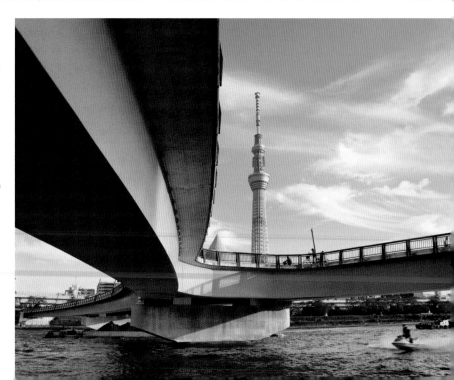

Left A crewman takes a break on the stern of a tugboat passing under Azumabashi Bridge.

Right A sailing ship's mast with maritime signal flags is the symbol of Takeshiba Passenger Terminal for Izu Island ferries and Tokyo cruise boats.

pleasant conveyance to Odaiba and up the Sumida River to Hamarikyu Gardens, Ryogoku, and Asakusa.

The relatively new Sumida River Terrace is a walking promenade that can be hiked past sixteen different bridges from Asakusa's Azumabashi downstream to Kachidoki Bridge at Tsukishima Island and Tsukiji. If Tokyo's waterways seem a bit too subdued, with boats few and far between during daylight hours, just wait for night to fall. Like fireflies, vessels begin to appear as the sky darkens, and soon the graceful *yakatabune* excursion boats with traditional paper lanterns are slicing through their own colorful reflections. Fishermen add more color, casting luminous floats from the river's shore.

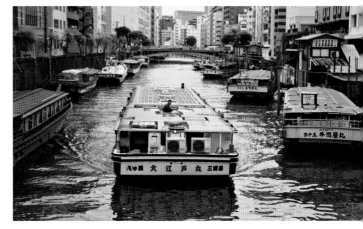

Above A pink upstart cruises past other *yakatabune* houseboats moored at the mouth of the Kanda River.

Dedicated to the legendary Tokyo authority, Donald Richie.

ACKNOWLEDGMENTS
For their kindest support and invaluable assistance, I am deeply indebted to Eric Oey, June Chong, Chan Sow Yun, Noor Azlina Yunus, Yuichi Kurakami, Yoko Yamada, Julia Nolet, Yuri and Takuji Yanagisawa, Don Morton, Isamu Nishida, Katharine Markulin and Koichi Hama, Barry Lancet, Naoto Ogo, Atsuro Komaki, Tomoko Minami, Rieko Matsumoto, Kinuta Ohba, Sarah and Greg Moon, Deborah and Vince Collier, Rebecca and Joe Stockwell, Kathryn Gremley, Marvin Jensen, Dennis Bones Carpenter, Will Taylor, Richard Cheatham, Ryoko Tsujimura, Yukie Suzuki, Reina Ogawa, Aya Tokito, Tomoyo Yasuda, Hans Krüger, and Tatsuhiko and Rika Tanaka. My heartfelt thanks to you all!

About Tuttle
"Books to Span the East and West"

Our core mission at Tuttle Publishing is to create books which bring people together one page at a time. Tuttle was founded in 1832 in the small New England town of Rutland, Vermont (USA). Our fundamental values remain as strong today as they were then—to publish best-in-class books informing the English-speaking world about the countries and peoples of Asia. The world has become a smaller place today and Asia's economic, cultural and political influence has expanded, yet the need for meaningful dialogue and information about this diverse region has never been greater. Since 1948, Tuttle has been a leader in publishing books on the cultures, arts, cuisines, languages and literatures of Asia. Our authors and photographers have won numerous awards and Tuttle has published thousands of books on subjects ranging from martial arts to paper crafts. We welcome you to explore the wealth of information available on Asia at **www.tuttlepublishing.com.**